The DC Comics Guide to
COLORING AND LETTERING
Comics

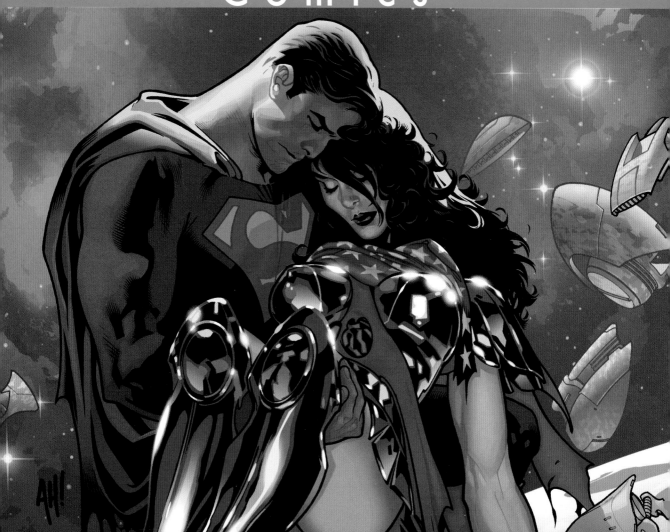

MARK CHIARELLO AND
TODD KLEIN

mics Guide to

ORING AND
TTERING

Comics

WATSON-GUPTILL PUBLICATIONS/NEW YORK

Senior Acquisitions Editor: Candace Raney

Senior Editor: Jacqueline Ching

Production Manager: Hector Campbell

Cover and Interior Design: Kapo Ng

First published in 2004 by Watson-Guptill Publications,

Nielsen Business Media, a division of The Nielsen Company

770 Broadway, New York, NY 10003

www.watsonguptill.com

Library of Congress Cataloging-in-Publication Data

Chiarello, Mark.
 The DC Comics guide to coloring and lettering comics / by Mark Chiarello and Todd Klein;
 introduction by Jim Steranko.
 p. cm.
Includes index.
 ISBN-13: 978-0-8230-1030-1
 ISBN-10: 0-8230-1030-9
 1. Comic books, strips, etc.--Technique. 2. Cartooning--Technique. 3. Lettering--Technique.
I. Klein, Todd. II. DC Comics, Inc. III. Title.
NC1764.C494 2004
]741.5--dc22 2004009753

This book was set in *Times New Roman*.

Printed in China • First printing, 2002 • 5 6 7 8 9 / 11

To Cathy, my favorite color.
Mark Chiarello

To the many fine letterers I've known, worked with, and learned from; and to my wife Ellen,
for putting up with my long hours in the studio.
Todd Klein

CONTENTS

INTRODUCTION

AWAKENED AESTHETIC: THE POWER OF COLOR

In the process that begins with a blank sheet of paper, the Art of Coloring Comics can be the most fun (imagine being paid for a Crayola habit) or the most frustrating (having your peers refer to you as the Jackson Pollock of Comics). The act of selecting colors and integrating them within a panel frame requires skill similar to that of painting—except the image is already there.

So, what's the big deal? More than you realize.

Early "craftsmen" painted men's suits green and orange (so readers could easily keep track of characters), never dreaming that color could be used to help build narrative sequences, shift attention from one panel to another, punch up dramatic beats, generate atmosphere, create compositional balance, define emotions, heighten suspense and mystery, suggest heat and cold and desolation, even articulate flashbacks. Consequently, the icons who shouldered the comics universe for generations failed to embrace one of the most effective weapons available in their limited graphic arsenal: *color.*

If you doubt it, look at almost any comic published before 1985, apply the ideological concepts within these pages, and you'll discover, more often than not, that color was simply another aspect of the assembly-line mentality that defined the medium—a *stagnant* element maintained by those who simply lacked the vision, talent, or courage to expand comics' dimensions beyond the stereotypical form it had become.

Two reasons: the first is that (with the exception of comic-strip creators who colored their own material) the work was relegated to non-artists, a few of whom might qualify as craftsmen. The second is that page rates were minimal; colorists on salary had to produce ten or more pages in an average workday (those with authentic artistic ability soon became pencillers or inkers). Instead of being provocative and inspirational, the result was often rushed, insipid, undramatic, confusing, or absurd—and failed to enhance the storytelling process, which is *the heart of the comics form.*

Instead of serving the material, it often did the opposite. Believe it or not, coloring was frequently left *to the printer!*

While it might seem sacrilegious to state, few, if any, artists and editors considered coloring as important as words and pictures, never quite understanding that

good color can make a bad image *appealing* and that bad color can *destroy* an extraordinary image. Fortunately, their trivialization began to dissipate, primarily due to the self-conscious concerns of a new wave of creators who muscled the old guard out of their complacent niches.

When digital color materialized in the '80s, the option of coloring was thrust into creators' hands (though not every creator can color). More importantly, the process was transformed by the possibility of utilizing millions of colors (previously, only a few dozen were available) and a spectrum of volatile and precise special FX. Predictably, the new weapon was abused as much as it was used with integrity; nevertheless, it caused color to become an *equal* element in comics' artistic equation (and one so important that I've christened the period from 1985 to the present The Digital Age of Comics.)

While much has been published about writing and drawing, the dynamics of coloring and lettering have been essentially ignored. Fortunately, this volume resolves that oversight.

Author/artist/designer Mark Chiarello has demonstrated his mastery of color in every medium from paint to Photoshop, and his expressive models here are designed to raise the aesthetic consciousness of those who read comics and those who create them, amateurs and experts, fans and pros alike. Within these pages, he reveals the secrets of his art, from the prototypical basics to the explicitly experimental, from creating coherent, dramatic color to the intricacies of its psychological use—and beyond.

Calligraphic wizard Todd Klein mirrors the achievement with his overview on matters typographic, demonstrating that the Art of Lettering can be no less challenging than the other aspects which involve the puzzle of producing superior comics—a seamless collaboration between the eye, the heart, and the imagination.

STERANKO

Jim Steranko is a writer, musician, art director, illustrator, magician, pop-culture lecturer, fire-eater, editor, designer, escape artist, and publisher, in addition to being one of the first of a new wave of creators who muscled the old guard out of their complacent niches.

PART

ONE

COLORING

Throughout the history of comic books, coloring was never considered very important. It was always a rushed, last-minute part of the creative process, and very rarely thought of as creative. Well, times change. Coloring is now considered by many to be as important to comic books as any other aspect of the creative process. Without a good colorist, the visual punch and appeal of a comic book is in jeopardy.

We've all seen dozens of examples of mediocre art jobs that were "saved" by great coloring jobs. Where mood, dimension, depth, and atmosphere are absent in the pencils and inks, a talented colorist can supply all of those life-giving elements. Conversely, we've seen first-rate artwork ruined by uninspired, hack coloring. Finely rendered and inked comics have been deflated too many times by coloring that was bland or garish.

The goal of an effective colorist is the same as that of every other creator working on a comic: to tell a clear and engaging story. Many skills contribute to this objective, including being able to set a mood, flow a story through different scenes, and support the dramatic intentions of the writer and artists.

The first part of this book deals with the complex aesthetic question: "How do I choose colors?" The answer can be incredibly simple or ridiculously complex. The second part takes an in-depth look at the computer and the remarkable role it has played in the art of coloring comic books.

A comic's coloring is a lot like the soundtrack of a movie. It's something that's subtle, yet always present. It's best when it doesn't draw attention to itself, yet can on occasion be quite powerful and memorable. When it flows and adds to the rest of the elements in a comic, it makes a comic book story whole.

There's nothing worse than bad or inappropriate music and/or sound effects in a movie. They stick out like a sore thumb, dragging down the rest of the pieces that make up the film. Comic book coloring also becomes terribly conspicuous when it's not done well. The greatest drawing in the world isn't good enough to overcome offensive coloring.

When I was a kid, comic books (much like life) were quite simple. By spending fifteen cents or a quarter on a comic, I could be sure I was getting a pretty straightforward action/adventure story aimed at a kid my age. The writing and art were designed to tell a story in a simple manner. After all, it *was* a comic book.

Over the years, comic stories and art got more complex. As comic stories started appealing to more sophisticated tastes, so did the artwork. Rather than being content with the same old look, some artists started creating comics using different mediums and approaches. The late 1970's and early 1980's saw the advent of fully painted comics, European-styled "blue-line" coloring, and, most significantly, digitally colored comics.

BRIEF HISTORY OF COMIC BOOK COLORING

Just as it's hard to imagine our lives without computers at work, in schools, and at home, it's astounding to consider how comic books were once colored. Today, all comics are colored and separated on computers, but until the mid-1980's, the process was quite arcane and archaic. Here's how it used to work:

Once the black-and-white artwork for a comic book was drawn and lettered, the editor (or more likely the editor's assistant) would photocopy the pages down onto 8 1/2″ x 11″ typing paper.

Using markers or watercolors or, most often Dr. Martin's dyes (very brightly colored, concentrated inks that come in small bottles), the

colorist would apply colors to the entire story, making sure to get all of the character's costume colors correct. These colored photocopies were called color guides. The colorist picked the colors he or she could use from a large chart that was provided by the publisher.

Originally, the colorist only had 63 colors to choose from, but in the 1970's the list was expanded to 124 colors. The actual coloring was fun, because it was a lot like filling in a coloring book when you were a kid, only you got paid for it (remember, that's *very* important!).

Before computers entered the picture, color "guides" were created with markers or transparent inks painted onto reduced size photocopies. Color codes were then added. From *The Brave and the Bold* #86 (October 1969). Script: Bob Haney. Art: Neal Adams.

Then came the tedious and somewhat baffling part: In order for the separator to discern *exactly* which colors the colorist wanted, he had to write down short codes for *every* color on the guides. If he chose a specific green, for example, that was the only way to make sure that exact green made it onto the printed comic page. Each color on the chart had a corresponding code, and the coloring wasn't complete until the colorist coded the stack of photocopies.

This secret language is no longer used in today's coloring, so don't worry about memorizing such confusing codes as Y2R2B3 and YRB4.

At this point, the colorist handed in these color guides to the editor and got paid for the work. A few months later, the colorist got to see the fruits of his or her labor when the printed comic hit the stands. Most colorists had very little idea of how their painted and coded guides got from that stage to the final publication. Here's how it worked: The comic book company's production department would send out the coloring guides and original art boards to their separator, where a group of old ladies would sit around applying dark brown paint to acetate copies of the artwork. I swear, it's true! A room full of women who were making minimum wage would darken in four sheets of acetate for each comic book page. Using the colorist's original color guides as a roadmap, they would apply varying shades of the dark brown paint to the clear acetate, making camera-ready film that could then be photographed onto four metal printing plates. The four sheets would correspond to the four colors required for printing: one each for yellow, magenta, cyan, and black.

This process of hand-painting the film lasted from the inception of the comic book in the 1930's all the way to the early 1980's. At that time, the widespread availability of computers was having a great effect on many aspects of life and business. Someone got the brilliant idea that you could get rid of all that yucky brown paint and instead use a computer to create camera-ready film. After a few bumpy years of trial and error, every comic book company in the land adopted the computer as a friendly and indispensable tool in the creation of comics.

Today, if you want to color comics you have to use a computer. The second part of this book will show you how.

COLORING BASICS

Separations: Picking the colors for a comic book page is only half of the job. Somehow the publisher has to get those colors to the printer in a form that can be translated to a printing plate. In this computer age, that means an electronic, digital file has to be created. These files are called separations.

Of all the different jobs that a comic book professional can have: writer, penciller, inker, letterer, colorist, and editor, coloring is the most fun and stress-free (although when faced with the occasional deadline crunch, it might not seem so!). As I've said, it's a lot like being a kid and coloring in your coloring book. Of course, it's not a job or art form that's suited for everyone. There are a lot of colorists who think they can put down *any* color and it will look good. They're wrong and they won't last in the business. The goal of this book is to show you what you'll need to know to fine-tune your color sense and become a very good colorist.

Before we start, here are the basics of color for print media, including books, magazines, posters, and comics:

All comic book colors are made up of three basic primary colors (or three basic printer's ink colors): yellow, magenta, and cyan. These are the building blocks of all colors. (Black is also a color, as well as a printer's ink color, but for now, let's just think of black as the color of the linework in a comic book.)

Every color on the comic book coloring chart is made up of variations of yellow, magenta, and cyan. By mixing and matching percentages of these basic colors together, you can come up with just about any color you would need to color a comic book.

Many people think that the three basic primary colors are yellow, red, and blue, but that's not true. Red is a combination of yellow and magenta. Magenta is a very intense, condensed pink.

Since there are so many versions of blue in the spectrum, it's important to define exactly which one is primary blue. That's cyan, a pure, intense sky blue. You can make all different kinds of blues by adding different percentages of magenta and yellow to cyan, but the base blue in printing is cyan.

TWO
THE PRINCIPLES OF COLOR

As a wise man once said, "Rule #1 is *follow the rules*. Once you learn and apply the rules, then you can break them."

Picking colors is easy, but how do you pick the most *effective colors*? How do you choose colors that will add to the impact of the story that you're telling? In trying to make that answer simple, I've broken the basic theories (or attributes) of coloring into five fundamental principles of color. When you're coloring, they should always be in the front of your mind, and you should always juggle three, four, or even all five of them in combination as you work.

Here are the five fundamental principles of color:

1. HUE
2. COMPLEMENTARY COLORS
3. VALUE
4. INTENSITY
5. COLOR TEMPERATURE

HUE

Simply put, hue is what we think of as the color of an object. The fire truck is *red,* the pumpkin is *orange,* the shirt is *purple*.

Throughout most of the history of comic books, the primary job of the colorist was simply to get all of the colors *right*. The right color of the Flash's costume is red. The right color of the sky is blue. The right color of the grass is green. There wasn't a lot of need or incentive for much more creative thinking than that, until someone said, "Hey, wait a minute. What if this scene takes place at dusk? Or on a cloudy day? I don't always want to color the sky blue." This is where artistic style came into the picture. In the early 1980's, because colorists were getting more creative and daring, individual colorists' styles became identifiable.

Ask yourself a question: what are your favorite colors? Personally, I'm partial to "school-bus yellow" and "olive green" and the many variations of "green/blue" (or aquamarine). I like these colors, so I use these colors. They are the choices that only I as an individual can make. Out of these choices comes an artist's personal style.

Complementary is a fancy word for *opposite*. Everything is intensified by its opposite. If you're an artist, you probably know the opposite of red is green, the opposite of blue is orange, and the opposite of purple is yellow. If you didn't already know that and you don't believe me, look at this color photograph and its accompanying negative.

In the photograph, the girl's hat is bright red, but in the reverse negative, it appears to be dark green. This proves that the opposite of red is green and the opposite of bright (or light) is dark.

You can buy a color wheel at an art supply store that will show you every color and its complement, but I'll save you a few dollars by reproducing a simple one below.

It's a useful reference when you're first starting out. You'll learn the basics pretty quickly.

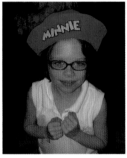
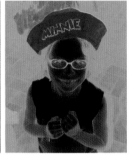

So how do you apply this complementary knowledge to coloring? Let's say you're coloring a page or cover or panel that features the Flash. Since the Flash wears a red costume, you can take advantage of green, which is the complement of red. By making the background green, you can help "pop" the character off of the page.

When applying this theory, remember to vary the foreground and background colors. Since the Flash's uniform is *bright* red, the green you pick for the background shouldn't be a *bright* green. There are thousands of greens to choose from, so consider one that's duller or grayer or darker or lighter than the Flash's costume (the next two principles, value and intensity, address this in greater detail). Another good reason not to pick a *bright* green is, unless there has been a nuclear explosion in your story, the bright green sky and buildings are going to look pretty silly.

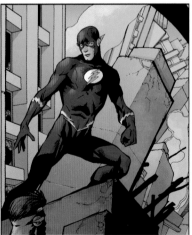

By contrasting the vibrant red of the Flash's costume with a dull green/gray (the opposite of red) background, the Flash's figure appears to advance to the foreground. In the second panel, although the background is indeed green, the green that's been chosen is so vibrant that it competes with the brightness of the Flash's costume, making the scene look unnatural. From *Flash* #208 (May 2004). Pencils: Howard Porter. Inks: Livesay.

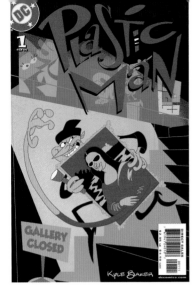
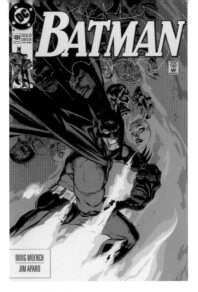

Complementary colors at work: The bright red of Plastic Man pops off the greenish wall behind it, Batman's blue/gray color scheme sets him clearly apart from the complementary orange background, and Wonder Woman's purplish tone is effectively given dimension by using a complementary yellow background. From *Plastic Man* #1 (February 2004). Art: Kyle Baker. From *Batman* #484 (September 1992). Art: Michael Golden. From *Wonder Woman* #200 (March 2004). Art: Brian Stelfreeze.

In this book, I often use the word *pop,* as in "to make a character pop." By this I'm referring to the technique of making an object appear to come forward and pop off of the page. Usually, you'll want anything that is the focal point of a panel (people, vehicles, energy blasts, and sound effects) to appear to advance towards the reader.

Right: Although much of today's coloring leans toward a darker palette, it can often get too dark. In the first panel, a dark, moody image of Batman is flattened out by the equally dark background. The second panel shows how lightening the background adds depth to the scene while still allowing it to be moody. From *Legends of the DCU* #6. Script: Kelley Puckett. Pencils: Dave Taylor. Inks: Kevin Nowlan.

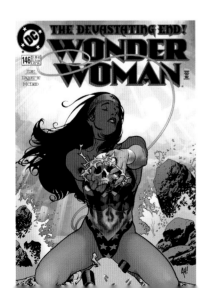

VALUE

This is the easiest principle to understand, yet it's probably the most ignored and underappreciated one.

Every color is either dark or light to some degree. There are dark blues and light blues; dark reds and light reds. A character that features dark colors should not be

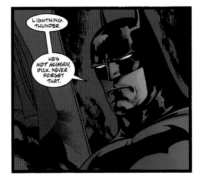

placed against a background of equally dark colors. If for some reason they are, there will be very little separation between the figure and its surroundings. By placing that same dark character in a medium or light environment, the intended focal point (the character) is emphasized.

To test this, take a page you've colored and photocopy it on a black-and-white photocopy machine (or, if you're working on a computer, change your CMYK color file to a grayscale file). All of your colors will turn into

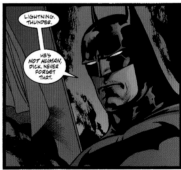

Mood can be accentuated by varying the value of a character's colors in relation to its background. Here, the perilous situation faced by Wonder Woman is heightened by the colorist's use of contrasting values. From *Wonder Woman* #146 (July 1999). Art: Adam Hughes.

variations of light gray to dark gray. If you're coloring correctly, your black-and-white copy should show the full spectrum of grays, including white for your lightest areas and black for your darkest.

The first page has been colored using a wide variety of dark and light colors. Next to it is a black-and-white copy of the same page, which shows more clearly that many different values have indeed been effectively used. Example #3 is the same page, this time colored only with dark colors. As you can see from the final graytone version of that page, all sense of drama and dimensionality has been lost. From *Batman* #623 (March 2004). Pencils and inks: Eduardo Risso. Colors: Patricia Mulvihill.

On the other hand, if you notice that most of the graytones are too similar, say all about 40 percent gray, then you're not varying your value scale enough. This makes for a monotonous page. A common mistake of computer colorists is to color too darkly. The factors that contribute to this unfortunate trend are many and are discussed throughout the second half of this book.

Making a color lighter in value is easy. If you're painting in oils (or any opaque medium), you add white. If you're painting in watercolor (or any transparent media), you add more water, which allows more of the white paper to show through the colored pigment. When working on a computer for a printed medium, including comics, magazines, and posters, you need to pick colors that call for less ink to be used. Say you're starting with a color made up of 100 percent cyan and 50 percent magenta. If you cut those percentages in half, you end up with the same color, but a lighter value (50 percent cyan and 25 percent magenta).

Years ago, when comic book coloring involved creating guides and coding each color, you had to do such calculations in your head. By logically and mathematically subtracting percentages of ink you could lighten your base color (for example, going from 100 percent magenta to 25 percent magenta). By adding percentages of ink (going from 25 percent magenta to 100 percent magenta), you would darken colors.

In lightening or darkening color, it was always extremely important to add or subtract percentages in equal amounts. In other words, if you're taking away *half* of the cyan, you should also take away *half* of the magenta. If you ignore this rule, and take out different percentages of the primary colors, you'll end up with a different hue than your original color.

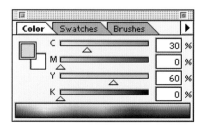

Now that coloring is done on a computer, the software Photoshop makes it easy to alter your color choices and keep track of these changes by using the handy color slider.

Making a color darker in value is achieved somewhat differently. Instinct tells us that if we lightened colors by adding white, then we should darken colors by adding black. Wrong! To darken a color, you add its tertiary color.

This is classic "comic book red," the one that we see in so many super hero costumes and sound effects. It's made up of full-strength magenta mixed with full-strength yellow. Its code is 100 percent magenta, 100 percent yellow. You've already learned that if you want to lighten it, you subtract equal parts of magenta and yellow. But if you want to darken it, you start adding small amounts of the third primary color—called its tertiary color—in this case cyan.

If your starting color is made up of two primary ink colors, then just add the third primary to darken. If your starting color is made up of one primary ink color, you'll have to add equal percentages of the other two primary ink colors to darken.

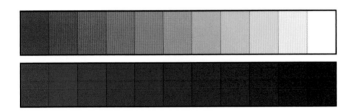

INTENSITY

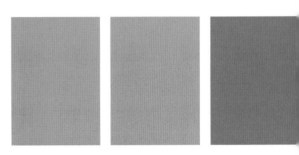

A color's intensity describes its purity. (This is also known as a color's chroma, but I think that's too fancy a word to remember.)

If you pick a color that is made up only of one primary color—let's say 50 percent magenta—that is a very pure, intense color. Now if you add a second primary color—let's say 50 percent yellow—to that magenta, you get a more interesting color, but one that is still very intense and still pretty pure. When you add that third primary color—let's say 50 percent cyan—to the other two, you create a less intense color. These are known as *dirty* or *dull* or *complex* colors.

Complex colors are a great tool in the world of bright, flashy super heroes. Since so many heroes and villains are clad in bright reds, blues, greens, and purples, it's great to be able to diminish backgrounds and less important objects in favor of the stars of our stories.

21

The bright, primary colors of comic book characters can be contrasted effectively with grayed down, less saturated backgrounds. This holds true for both flashy super heroes and "regular" guys. *Above right:* From *JLA/Haven: Arrival* (2001). Script: Ashley-Jayne Nicolaus and Matthew P. Schuster. Pencils and inks: Ariel Olivetti. Colors: Rob and Alex Bleyaert. *Right:* From *Action Comics* #792 (August 2002). Script: Joe Kelly. Pencils: Pascual Ferry. Inks: Mark Morales. Colors: Moose Baumann.

Traditionally, heroes are colored in pure, primary reds, blues, and yellows. Think of the patriotic uniforms of Superman, Captain America, and Wonder Woman; the vivid red suits of the Flash, Captain Marvel, and Plastic Man. Contrary to these good guys, the villains are usually depicted in secondary and sometimes tertiary color schemes: the purple and green costumes of the Joker, the Riddler, and the Green Goblin; the gray and blue of Darkseid.

To give a twist to the traditional hero, dark and tormented good guys are often presented in the same non-primary colors that adorn the bad guys. Batman's dark blue and gray, the Hulk's green skin and purple pants, and Martian Manhunter's green skin all reflect the classic anti-hero.

Since grays and browns are made up of three-color mixes, they're classic complex colors. After you have colored your super heroes in their traditionally bright, pure colors, complex colors are great for backgrounds, buildings, and furniture—anything that's not the focus of a panel or page.

COLOR TEMPERATURE

When I was in art school, my teachers kept referring to colors as being warm or cool. Although I nodded my head and agreed with what they were saying, I actually didn't have the slightest idea of what they were talking about.

Fortunately, I later learned what all the fuss was about and was able to apply the theory to much of my own artwork.

Warm colors are those that pop off of the page. Reds, oranges, yellows usually create a sharp focus, whereas cool colors (blues, most greens, most grays) recede in space. Think about the colors you associate with the hot desert, or how you visualize the fires of hell. Those are the warm colors of

Colors from the yellow/orange/red end of the spectrum are referred to as warm colors. *Left:* From *Superman: The Man of Steel* #55 (April 1996). Pencils: Jon Bogdanove. Inks: Dennis Janke. Colors: David Baron. *Center:* From *JLA* #85 (October 2003). Pencils: Doug Mahnke. Inks: Tom Nguyen. Colors: David Baron. *Right:* The cool blue shadow colors of the city contrast nicely with the warm tones of the sun and sky. This technique gives this scene a simple, yet effective, sense of believability. From *Action Comics* #792 (August 2002). Script: Joe Kelly. Pencils: Pascual Ferry. Inks: Mark Morales. Colors: Moose Baumann.

the spectrum. They suggest noise, anger, danger, and intensity. Now, think about the blue/purple colors of shadows on a snowy landscape, or the calm, serene, cool blues of the sea. These are the cool colors of the spectrum.

OTHER PRINCIPLES

If you visit a museum that exhibits traditional landscape paintings, take a good look at a few. You'll notice that objects (such as mountains) get bluer and lighter as they go back in space. Objects in the

Left: The variety of blues, blue/greens and bluish-grays make up the cool portion of the color spectrum. From *The New Frontier* #1 (March 2004). Script, pencils, and inks: Darwyn Cooke. Colors: Dave Stewart.
Center: From *The Legion* #1 (December 2001). Pencils: Olivier Coipel. Inks: Andy Lanning. Colors: Rich and Tanya Horie.
Right: As in nature, warm skintones stand out against warm blue sky colors. From *Wonder Woman* #178 (April 2002). Art: Adam Hughes.

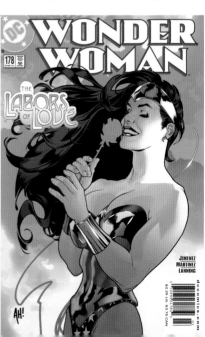

foreground are sharp and clear and usually warmer in tone than objects in the middle ground or background. This theory is called aerial perspective and is discussed in greater depth on page 29.

This theory can be very effective when applied correctly in comics. Because an individual comic panel or cover is a flat representation of people and objects in space, anything a colorist can do to add to the illusion of depth and space is of utmost importance. After all, comic book artists (pencillers, inkers, and colorists) are trying to replicate real three-dimensional life in a two-dimensional medium. One of the best tools in this pursuit is the use of color temperature, warm and cool.

Take a look at the cubes below.

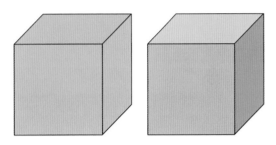

The left one is colored on all sides using the same flat yellow base color. The right cube, however, appears to be much more dimensional because two color theories are brought into play. The side that faces front stays the same yellow base color. The topmost plane is lightened to give the appearance that a light source is shining directly on this side. This uses the theory of value, in this case giving an object definition by lightening a portion of it. The right hand side of the cube utilizes the temperature theory of color. By adding a bit of blue to the base yellow color, it appears that the right side of the cube is the furthest away from the light source. Remember that objects in direct sunlight are warm; objects in shadow are cool. This basic rule can be applied to any object of any complexity.

Because so many heroes and villains are colored in warm reds, yellows, oranges, and purples, they pop off the background naturally. It also helps that skin tones are almost always represented with warm colors. Therefore, cool blues, purples, or grays work well on backgrounds.

In the case of a character that sports a cool blue costume, your job is a little trickier. The options are:
- Rim the character with warm secondary or reflective lighting so that at least a portion of the character will advance. Rim lighting is a bright highlight on the side of an object used to suggest a secondary light source.
- Pick warm colors for the background. This way, you will at least achieve some separation between foreground and middle-ground objects. You will, however, run the risk of having your background objects pop and your character recede. That's because you're actually breaking the basic rules of the color temperature theory.
- Rely more on color value than color temperature: dark characters on a light background or light characters on a dark background. Again, this will achieve your goal of separating the character from his surroundings.

Primary colors never vary in their temperature (unless you add overpowering amounts of their complementary hues to them). Red, yellow, and their offspring, orange, will remain warm colors. Blue will almost always remain cool. The colors that are comprised of warm/cool primary mixes (greens and purples) can go either way, depending on the dominating component. For example, green, which is made up of cyan and yellow, can look cool if there's more cyan in the mix, or look warm if there's more yellow in the mix.

SLISH

Think like the enemy.

FLP FLP

Top: By using warm rim lighting, contrasting foreground/background values, or warm background colors, you can still pop coolly colored characters. From *Batman: Hush* (2003). Script: Jeph Loeb. *Right:* Pencils: Jim Lee. Inks: Scott Williams. Colors: Alex Sinclair. From *Superman/Batman #1* (October 2003). Script: Jeph Loeb. Pencils: Ed McGuinness. Inks: Dexter Vines. Colors: Dave Stewart. *Above:* From *Batman: Death and the Maiden* (2004). Pencils and inks: Klaus Janson. Colors: Steve Buccellato.

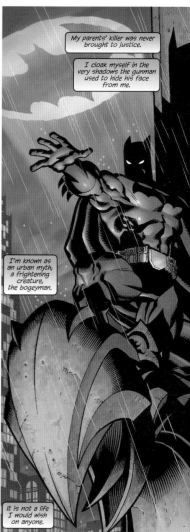

My parents' killer was never brought to justice.

I cloak myself in the very shadows the gunman used to hide his face from me.

I'm known as an urban myth, a frightening creature, the bogeyman.

It is not a life I would wish on anyone.

Purple also can appear to be either warm or cool, depending on the amounts of magenta or cyan you choose. The vast spectrum of grays can also be manipulated to lean towards warm or cool colors. For example, by adding a small bit of yellow to a neutral gray, you instantly change it into a warm color.

Alternately, add a bit of blue to that same neutral gray and you've got a cool gray.

COLOR SATURATION

Although not one of the five principles above, color saturation is an important part of any conversation about color, especially color that is going to be reproduced on a printed page.

Basically, saturation is how much ink makes up individual colors. For example, 25 percent magenta is a relatively light color because it's made up of very little ink, and this allows a lot of the white of the paper to show through. A relatively deeper, richer color is 100 percent magenta because more of the same color ink is being printed on the paper (see opposite page, top).

Other colors are made up of a lot of ink and give off a very dense, rich look: for example, 75 percent yellow, 100 percent magenta, and 75 percent cyan.

Although such colors can be very effective, using too many is just as bad as using too many light colors. An overabundance of darkly saturated colors tends to give the page a heavy, oppressive look and flattens the foreground, middle ground, and background into a two-dimensional jumble.

Similarly, using only very light, undersaturated colors on a page gives an overexposed, lightweight look to your work.

If you want to use *very* rich, saturated colors in one area (on people, for example), it's wise to counterbalance them with lighter, less saturated colors elsewhere in the same panel.

By setting these levels before you start coloring, the computer will sense any color you choose that is oversaturated and lighten those colors back down to no more than 240 percent total ink level. Once you preset the level, your computer will always remember it and perform this service on every subsequent page you color.

Some dark colors are made up of so much total ink that they appear almost black. Because they're so dark and saturated, linework is virtually lost on top of or next to them. Be aware of these colors and try to avoid using them.

Oversaturated colors tend to "heavy up" a page. The first example here shows how too much ink gives a flat, over-colored look to artwork. The version in the middle shows a good saturation and dark-to light-ratio. The last page has a lightweight, washed-out look because it was colored primarily with light, pastel colors. From *Mighty Love* (2004). Pencils and inks: Howard Chaykin. Colors: Dave Stewart.

THREE
STORYTELLING
WITH COLOR

Much in the same way a painter must visualize the finished painting before he even picks up a paint-brush, a colorist must "walk through" the scene he is about to color. It's a bit like watching a scene from a movie in your mind's eye: You must be able to choreograph it before you color it. What is the overall tone (color) of the scene? How about lighting? Shadows? What are the key points of interest and focus?

The first step in any coloring job—*before* you click a single pixel of color onto your scanned pages—is to read the entire story. This is so you'll know that on page seven, for example, when the narrator refers to it being "a cold and windy night," you'll know not to color the scene as a warm, sunny day. Reading the comic before you start coloring will also allow you to make sure you have all of the color reference you'll need to do the job. If a character you've never seen before appears in the story, call your editor and ask him to send you a published comic in which that character appeared.

The most important reason for reading through the story is to form a coloring "game plan" in your head. You've got to be able to flow the story from scene to scene using different and appropriate color schemes that change as the scenes change. The internal monologue in your head might go something like this:

"OK, scene number one takes place in a hospital, so I'll color that in light greens (because, those are the colors I personally associate with the stark, antiseptic world of hospitals). The main character exits the hospital in scene two, stepping outside into the nighttime city. For this scene, I picture predominantly deep blues (because it's nighttime, but also because I think of cities as cold places), with maybe some warm yellow/orange light coming from a few windows. Scene three takes us to the interior of a governmental science lab that's filled with enormous machinery. I can visualize this as mostly variations of cool grays, especially in the middle ground and background, with maybe some warm grays in the foreground and around the lead characters."

This should give you an the idea of what I mean by a coloring game plan. After you've run through the six or eight or ten scenes in your comic this way, you're prepared to start the actual application of color.

Next, sit down and attack scene number one, remembering that you visualized the hospital scene with green as your predominant color. Don't color every bit of clothing and every background item green, or the scene will look like it takes place in leprechaun land. By coloring the walls and the uniforms of the medical staff a pleasant green, you're setting up a recognizable color scheme that reminds the reader that this setting is indeed taking place in a hospital, without beating them over the head. If you've done your job correctly, your game plan will never be obvious to the reader, but will subliminally ease him through the story from scene to scene.

The first 12 pages from *100 Bullets* #35 (June 2002) demonstrate how an effective colorist subtly shifts color schemes from scene to scene. The first two pages (the prologue of the story) are colored in gray tones. The next three pages have a bluish nighttime color scheme. When the scene shifts back to the car from the prologue, we shift back to grays for two pages. The next scene, which takes place indoors, consists of alternating blues and oranges, to show interior lighting for three pages. Finally, for the last scene, the palette shifts to washed-out yellows, which give the feel of stark midday sunlight. Script: Brian Azzarello. Pencils and inks: Eduardo Risso. Colors: Patricia Mulvihill.

When picking green colors for that hospital scene, which ones should you choose? Of the hundreds of greens, which ones are the most appropriate for the mood that you're trying to set up? Well, hospitals are supposed to be calm, quiet places, so you'll want to avoid the more the saturated, bright and garish greens. You should be leaning towards the light, serene, warm greens.

You don't have to be Einstein to know it's all relative. A light green color looks green when it's by itself, but when you put it next to a bright, saturated green, it looks less green, almost white.

Right: Here's proof that a color can change its appearance in contrast to the colors placed around it. The green inner squares may look different, but they're actually the same color. The white framing the inner green square at the top makes the green look slightly darker, while the color framing the inner green square at the bottom makes it appear lighter.

FOCUS

A major part of the colorist's job is to create focus. In an effort to lead the reader's eye through panels and across pages, the colorist must first decide the most important thing in each panel, on each page. The question "What is the center of interest?" is at the heart of storytelling. By contrasting the color of different elements and objects, the colorist can attract the reader's eye to exactly where he wants it to go.

Use any or all of the following principles of color to aid you in this constant goal.

Because comic book artwork is usually very detailed and elaborate, the colorist has to decide where the reader's eye should go on each page and in each panel. In the first panel, a homeless man confronts Superman, making his point by banging on the Man of Steel's chest. In panel two, the colorist has darkened Pa Kent's colors, which leads our eye right to the "normally" colored Clark. On the Deadman cover, the character's bright white face is clearly the focus amid a sea of red. Here, even the Deadman logo was colored red, so as not to detract from the white skintone. On the Batman cover, by making the blood-stained floor the only reddish color in an otherwise blue/gray image, the reader can't help but focus directly on what the artist intended. From *Action Comics* #798 (February 2003). Script: Joe Kelly. Pencils and inks: Pascual Ferry. Colors: Moose Baumann. From *Superman Birthright* #3 (November 2003). Script: Mark Waid. Pencils: Leinil Yu. Inks: Gerry Alanguilan. Colors: Dave McCaig. From *Deadman* #4 (May 2002). Pencils and inks: Mike Mignola. Colors: Mark Chiarello. From *Batman: Gotham Knights* #26 (April 2002). Art: Brian Bolland.

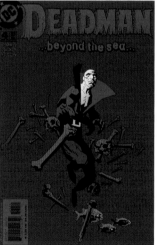

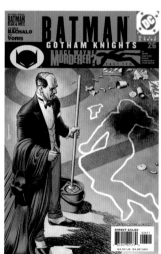

Opposite: In both examples, objects in the foreground are colored with darker, richer colors. The farther back in space they go, the lighter and bluer they become. You'll notice that the buildings in the far distance of the Wonder Woman cover are almost as light and as blue as the faraway sky. This gives a true illusion of depth and distance. From *Wonder Woman* #177 (March 2002). Art: Adam Hughes. From *Mighty Love* (2004). Pencils and inks: Howard Chaykin. Colors: Dave Stewart.

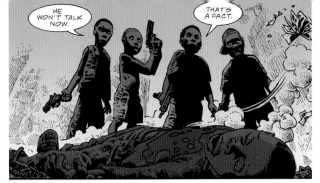
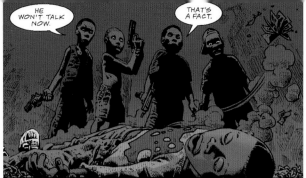

Because the background in panel #1 is colored lightly, the four kids in the midground become the focus of this scene. Panel #2 shows the same image, but by coloring the dead foreground character in the brightest colors of the panel, he becomes the focus. From *Batman: Black and White* (1996). Script: Jan Strnad. Pencils and inks: Richard Corben.

DEPTH

Often, the artist will draw figures, characters, and objects on several different planes in a single panel. As the colorist, it's your job not only to separate the foreground, middle ground, and background planes, but also to lead the reader's eye directly to the most important (focal) plane of the panel.

This illusion of depth was used to great advantage in the early days of animation by the Walt Disney Studios. The gang at Disney created and used an ingenious camera, called the multiplane camera, which was able to photograph four or five different backgrounds at varying distances from the camera. When filmed simultaneously, the background paintings closest to the camera stayed in sharp focus, while the ones further away appeared lighter in tone. You can do essentially the same thing by varying the value (darkness/lightness) and/or the color intensity or saturation between planes.

At first, think in simple terms when separating planes: darkest values and full-strength color in the foreground, lighter values in the middle ground, and lightest values in the background. Once you practice the basics, then mix the rules around a bit. Maybe you can make all foreground objects light and bright, middle ground objects a bit darker and background objects the darkest.

AERIAL PERSPECTIVE

One very effective technique for creating the illusion of far spatial depth and very believable distant backgrounds is known as aerial perspective. Because our atmosphere is filled with tiny particles of

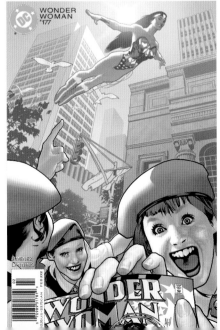

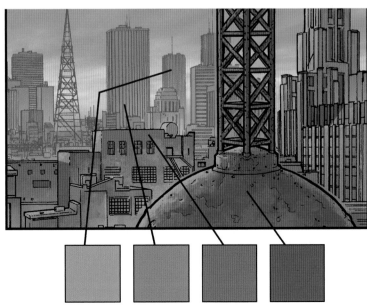

dust and water, objects that are very far away appear to be lighter, bluer, and less intense than those objects that are closer to us. According to master artist Leonardo da Vinci, the farther away your eye is from an object, the more dust and water particles begin to obscure your clear view of that object.

This theory can be readily applied to coloring comics. By lightening distant objects (both the color of the object *and* the linework of the object), it will appear that there is indeed space between the foreground and the background.

SELECTIVE REALISM

One theory concerning focus and point of interest in classical painting is called selective realism. It can be applied directly to comic book art, and especially comic book coloring. The theory puts forward that the human eye tends to grab onto the two or three most important objects in a piece of art and edits out or ignores all the rest. Even in an incredibly detailed illustration, the viewer's mind needs to hook onto only the most pertinent information.

In most traditional art forms, that focal point is usually the human face, hands, or figure. The same holds true for comic art: Our mind and eye follow the hero or villain through the book from the first page to the last.

The colorist's job is to aid the eye by sublimating the background or less important aspects in a panel. Because of the relatively short time frame that a comics reader's eye stays on a single panel, the colorist must help to direct the eye to the most pertinent information. By using color principles such as complementary color, color temperature, intensity, and value, a colorist can subliminally edit out all

From *JLA* #102 (August 2004). Pencils and inks: Ron Garney.

extraneous information. Obviously a comic book can't be drawn without backgrounds (even if that's what the eye subconsciously wants), so you have to take the emphasis away from any objects that need to fall outside of the reader's focus.

If you were to pick background colors randomly or chosen solely because they're nice or pleasing, regardless of their appropriateness to the scene, you'd probably end up with a confusing panel. In the first illustration at left, the background has been colored with bright, vibrant colors, which draws the reader's attention away from the foreground figure. Panel #2 shows a much more subdued background color scheme, which allows the Flash to rightfully remain the focus of the panel. The last panel demonstrates how the human eye sees panel #2, holding the reader's attention on the Flash, while almost ignoring the much less important background.

If you're an inker, you know that you have to approach each job differently than the last. Pencillers all have different and varying styles. You can't, and shouldn't, ink a very detailed, illustrative artist like Jim Lee the same way you would ink a more graphic and geometric artist like Mike Mignola. They think differently than one another about art, and in order to be true to the penciller's vision, the inker must also alter his methods and approach with each new job.

The same is true for colorists. Pages drawn by artists with a very high-contrast, graphic style, like Mike Mignola, Tim Sale, or Michael Allred, require a flat, traditional coloring style. Any shading should be linear, graphic and not too fussy.

Use of computer tools that round forms, such as the *airbrush* and *radial grad tool* would run contrary to the style of such an artist.

Notice how appropriate the modeling is in the second image below, whereas the fully rendered shading in the first one looks wrong. As the colorist, part of your job is to be the last leg on the art team and bring closure to the illustration. This can only be done by applying a suitable color job.

The opposite of the above example is equally apparent. If you're coloring pages that were drawn by a very detailed or line-intensive artist, like Jim Lee, Frank Quitely, or George Pérez, you need to get on their same wavelength with your coloring. Fully rendered, high-end computer coloring is most fitting here.

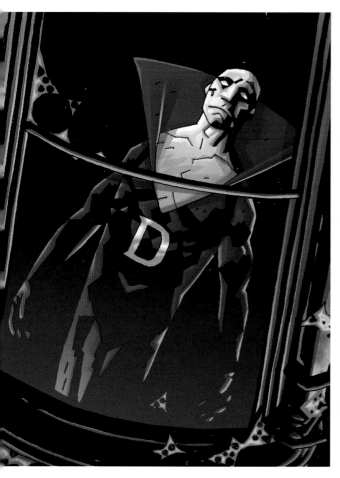 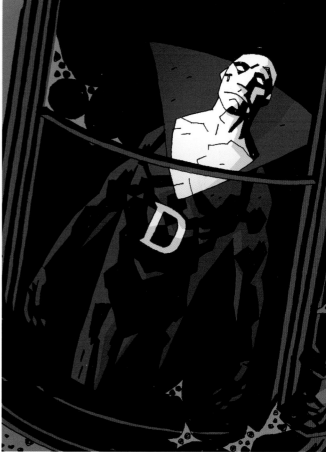

A clean, minimal art style calls for a clean, minimal color job. In panel #1, Mike Mignola's graphic drawing style has been over-rendered and over-modeled. The second panel shows a simpler, cleaner approach to coloring, which is much more appropriate for this type of artwork.

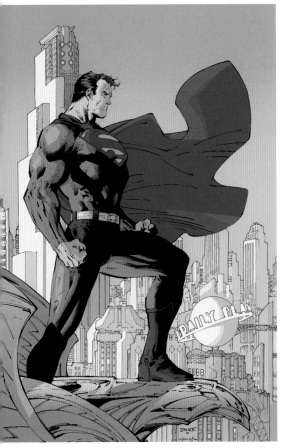

A flat, classic color job gives the artwork an almost childish, overly simple look.

Of course, it is possible to get carried away with too much modeling. As with any form of art, knowing when to stop is something that only experience can teach you.

There are dozens of variations to the above two styles. It is your job as colorist to determine which color approach is right for the art style you're working on.

MONOCHROMATIC PALETTE

An illustration or painting that uses primarily one color (hue) is called monochromatic. If used correctly, this is an incredibly potent approach to coloring. When coloring a flashback scene, it's nice to switch to a monochromatic palette because it immediately shows the shift from current time to the past. Because we've seen so many old sepia-tone or black-and-white photographs, we're accustomed to thinking of monochrome images as being from the past. This is also a technique that's used effectively in movies. When a character reflects back on his days in the war, for example, the screen might gradually become awash in a field of browns and sepia. By shifting into this monochromatic palette, the director or cinematographer signals to the audience that the time frame has changed to the past.

One fun and effective technique for creating flashbacks is to add a tint of color over an entire panel or scene. This is very similar to the way many old master oil painters would glaze their paintings with a thin wash of color. By tinting a panel or a page, you're creating what's called an analogous palette. Analogous colors are those that are close to one another in the spectrum. For example, reds are next to oranges, which are next to yellows. By limiting your choices to two or three related colors, you're creating a limited, analogous color palette.

You can easily accomplish the same thing several ways with the computer. Try this, just for fun: Select a panel that you've already fully colored. Now, pick a color, let's say a yellowish-brown. Fill the entire selection with the color (Edit: Fill), but at 50 percent opacity, instead of 100 percent, and in the Color mode, instead of the Normal mode (see opposite page).

Above: In contrast to the graphic image on the previous page, here's an example of how a high-end, lushly detailed color job complements highly detailed artwork. Alex Sinclair's elaborate color style fully complements Jim Lee's modern approach to super heroes. Panel #2 shows how a simple, graphic approach to coloring this type of artwork seems out of place and not in tune with the artist's vision. From *Superman* #204. Pencils: Jim Lee. Inks: Scott Williams. Colors: Alex Sinclair.

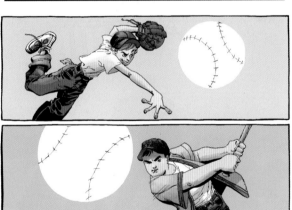

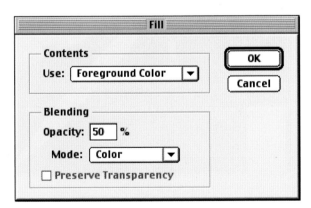

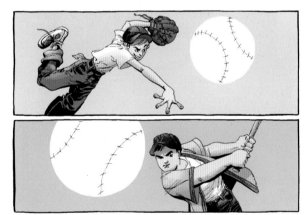

Top: Flashback sequences can be set aside from the rest of a comic story by coloring them in monochromatic colors. Here, the death of Bruce Wayne's parents takes on an otherworldly feel because it's been colored with an extremely limited palette. In the right-hand page, the sepia/brown flashback sequence contrasts nicely with the "normal" colors of "real" time. From *Batman* #623 (March 2004). Pencils and inks: Eduardo Risso. Colors: Patricia Mulvihill. From *Action Comics* #786 (February 2002). Script: Joe Kelly. Pencils: Pascual Ferry. Inks: Scott Hanna. Colors: Moose Baumann.

Middle: "Normal" colors can be given a bit more style by partially colorizing them. Here, a warm tone has been laid over the young baseball players on the right, giving the figures a warm, summertime feel.

You'll notice that your panel now has a neat flashback feel to it. Practice doing this using different colors and at different percentages.

This technique doesn't only work for flashback scenes. If you experiment a bit, you'll be able to colorize your regular scenes and achieve an engaging overall feeling to a scene. Many of today's movies are colorized in a similar way during the color-correction stage of film production. Not only are some individual scenes colored in an analogous pallet, but sometimes entire films are. Think about it: Overall, *The Matrix* is a green movie, *Gladiator* a golden movie, and *Raiders of the Lost Ark* a brown movie.

A word of caution: Don't overdo this technique. It's easy to get carried away to the point that virtually nothing is colored in its "normal" colors.

USING WHITE AND BLACK AS COLORS

Whereas most children think of white and black as actual colors, most adults think of white as the absence of color and black as the absence of light. When used in place of red, yellow, or blue as part of your coloring job, both white and black can be incredibly powerful assets.

Used judiciously, white is, by far, the most powerful of all colors. Its intensity and visual draw are stronger than even the brightest red or the most vibrant yellow. For this reason, it should be used

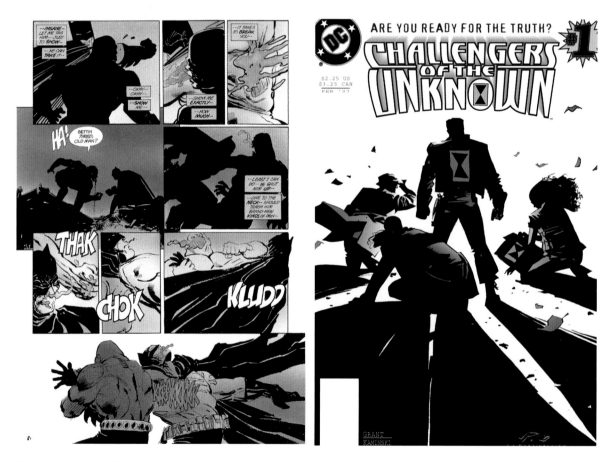

The power of white is clearly apparent in these panels. By using stark white in the last panel of page one, we feel the brutality of the moment as Batman's arm is broken. The following two images use white to suggest our heroes facing off against a force of indescribable power. From *Batman: The Dark Knight Returns* #2 (1986). Script and pencils: Frank Miller. Inks: Klaus Janson. Colors: Lynn Varley. From *Challengers of the Unknown* #1 (February 1997). Pencils: John Paul Leon. Inks: Shawn Martinbrough. Colors: Matt Hollingsworth.

as a secret weapon. When used as a visual punctuation at the key moment in a story (as the core color of an exploding planet or as the background color when the bad guy breaks the hero's arm), the use of white can be both shocking and memorable.

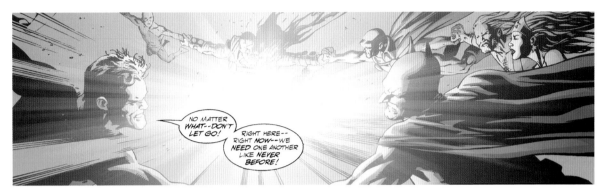

From *JLA: Heaven's Ladder* (2000). Script: Mark Waid. Pencils: Bryan Hitch. Inks: Paul Neary. Colors: Laura DePuy.

It is primarily for this reason that large areas of white should not be overused. (Of course, you'll use white in the gutters between panels and in word balloons, as the color of clouds and teeth and the whites of peoples' eyes.)

Because of the very nature of comic book art, black appears in abundance on almost every page of every comic. It's much more of a tool of the penciller and inker than it is of the colorist. Since those artists have already determined where all of the full strength blacks are placed on a page, there's no need for the colorist to ever add pure black.

However, smaller percentages of black ink can be added to color mixes. Like any other ink color (cyan, magenta, or yellow), black can be used in increments from 1 percent to 100 percent.

A very important note to keep in mind when using black ink to darken your colors is to never add more than 40 percent black to your color mix. The reason for this is fairly logical: Black tends to overwhelm any other color it's mixed with. Adding anything more than 40 percent black ink to another color will make that color appear oversaturated and unappealing.

Most colorists use black sparingly or avoid using it altogether, preferring to darken their colors by adding more cyan, magenta, or yellow to their color mix.

Once in a very rare while, you'll want to throw all of the rules of coloring out the window and use whatever colors your emotions tell you to. In fine art, this is referred to as expressionist painting. If your mood directs you to color a boy's face purple and his hair green, then that's okay. The paintings of Vincent van Gogh and Edvard Munch are prime examples of this approach to art and color. Keep in mind that these aren't random colors you're picking. They are colors that say something about you as a human being and communicate your emotions.

This type of coloring should only be done at the request of your editor and with the complete knowledge of the artist of the comic. Although comic book artists are usually mild mannered individuals, they may become homicidal maniacs if they receive a coloring job like this without their prior consent!

THE PSYCHOLOGY OF COLOR

While coloring a story in the normal fashion (as opposed to an expressionistic manner), you might want to add a panel or two that amplifies the extreme emotion of a scene. A madman in a murderous

Pure emotion can sometimes dictate your approach to coloring a specific story. Here are three examples where 'normal' colors were abandoned in order to convey the feelings of fear, nervousness, and paranoia. *Clockwise from right:* From *Heavy Liquid* #4 (2001). Script and art: Paul Pope. From *Showcase* #9 (August 1994). Script: Alan Grant. Art: Teddy Kristiansen. From *Detective Comics* #747 (August 2000). Script: Greg Rucka. Pencils: William Rosado. Inks: Steve Mitchell. Colors: WildStorm FX.

rage might be colored in bright reds. A couple finally experiencing their first kiss might be colored in cool, cozy blues. This type of coloring emphasizes a key moment in time and a memorable moment in the makeup of a character's psyche. These are the defining moments the characters and the reader will always remember

When coloring for effect this way, it's important not to go overboard and bring the scene to a complete halt. Too much or too extreme of a color shift might confuse the reader and draw him out of the flow of the story.

A cover, panel, or key scene of a comic can be accentuated by pumping up the emotion that's being depicted. *On the left,* insanity is shown as conflicting magenta and green. From *Rose and Thorn #2* (March 2004). Art: Adam Hughes. *Above,* the sheer terror of a moment is captured with hot reds. From *Gotham by Gaslight.* Pencils and inks: Mike Mignola.

Here, cool blues suggest a world of jazz and streetlife. From *Batman: Black and White* (1996). Script: Archie Goodwin. Pencils and inks: Jose Munoz.

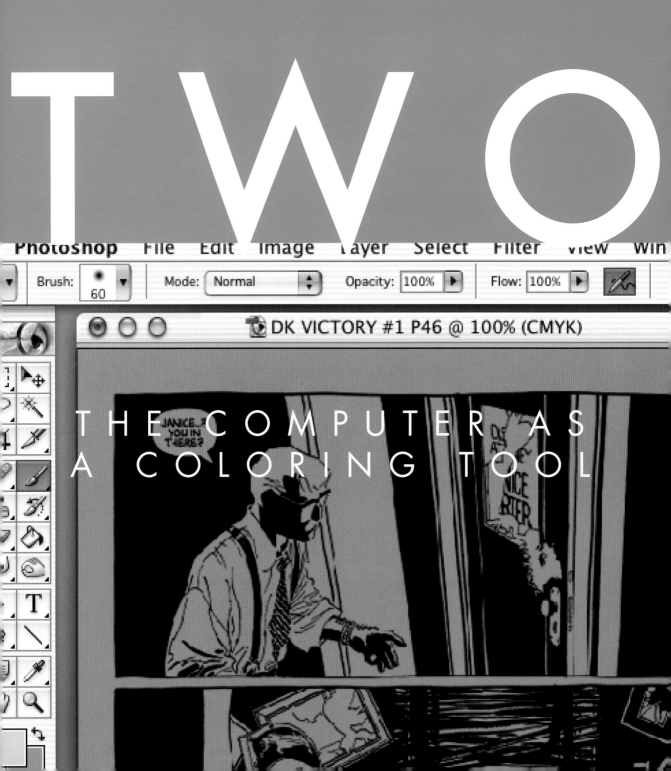

Over the past decade, I've heard about a million people say, "I hate computer coloring; it's ruining comics!" Although I understand the sentiment, it is absolutely absurd. Sure, some computer coloring is dark, over-rendered, and over-saturated, but a lot of it is also strikingly dramatic, superbly executed, and downright beautiful.

The problem with computer coloring isn't the computer's fault; it's the fault of the person using the computer. The computer is a coloring tool, in the same way that markers or dyes or watercolors are coloring tools. If you give a great set of markers to someone who's not an artist, the end result is most likely going to be pretty bad. The same holds true for computers. Just because you own a computer doesn't mean you're a colorist. Considering that nearly everyone on the planet owns a computer, there are going to be a lot of people out there producing a lot of awful coloring. However, in the hands of a trained artist, or someone with good taste and a keen aesthetic sense, the computer can be the finest coloring tool ever produced.

FOUR
COMPUTERS AND COMIC BOOK COLORING

The most important aspect of modern comic book coloring is the computer. If you're coloring on a computer, you're not merely the colorist the way traditional "guide" colorists were. Now, you're the colorist *and* the separator of the comic. Because you're translating the colors that you've chosen into digital files, you now have complete control over what your coloring will look like when printed (that is, *if* you take paper stock and printer's ink gain into consideration, but more on that later).

If you're coloring on a computer, you can't blame the separation house for lousy seps anymore. When you hit the Save button and send your disk to the publisher, no one else will translate or alter your colors as they have in the past (unless, of course, you have made some sort of color mistake that needs to be corrected by the publisher).

When you sit down at a computer to color an artist's pages, it's your responsibility to match your coloring style to his art style. Just because you *can* airbrush every plane of every muscle and put different light sources on every blade of grass, doesn't mean you should.

SOFTWARE CHOICE

Since Photoshop is available in both platforms, the choice between Mac and PC is yours. The vast majority of computer colorists, as well as most artists and designers creating desktop publishing, work on Macs. Keep in mind that just about all comics publishers accept *only* Mac files. Therefore, if you're working on a PC, you'll have to convert your finished PC Photoshop files over to Mac Photoshop files before you send them in to the publisher.

I can't tell you exactly which system or monitor to buy, since the choices are endless and constantly changing. Just keep in mind that if you buy a high-quality system, you'll reap the rewards of your investment. The major thing you're looking for in a Mac is RAM (random access memory) and processor speed. The more RAM you have, the smoother Photoshop will run and the faster your files will load and save. Many new systems now come with built-in CD burners, which is a *great* advantage for a computer colorist.

A quick word about the coloring program you'll be using. Adobe's Photoshop is the industry standard. Although there are some other good software programs out there, such as Corel Painter, Photoshop is what the pros use. It's an awesome program, one that will allow you to do everything with color that you can imagine. The following pages cover the many properties of Photoshop and the endless possibilities that it offers.

This section of the book is not meant as an introduction to Photoshop, but rather explains which Photoshop tools and techniques are used specifically to color comic books. Every few years, a new, upgraded version of Photoshop comes out. It's not necessary to run out and buy the newest version, but keep in mind that the good people at Adobe are constantly refining the software and making it a more powerful tool. If you are using an older version of Photoshop (I use 4.0 at home), some of the settings and information boxes will look different than those on the newer versions (I use 7.0 at work). For the purposes of this book, I've tried to show examples of both versions that I own. If you're using a different one, like 5.0, you might run across a tool, setting, or menu that looks slightly different than the ones I'm discussing.

MOUSE VS. GRAPHICS TABLET

Very few computer colorists use a mouse. Most prefer using a pressure-sensitive graphics tablet. The tablet is a flat drawing board that sits on the table in front of you. You "draw" on the surface of the tablet with a graphics pen in much the same way that you would draw with a pencil. The only difference is, instead of making marks on the tablet, the marks appear on the computer screen. It takes a good three or four days to get used to the process, but once you do, it feels as natural as drawing with a pencil. You'll find that going back to using a mouse will feel like trying to draw with a potato.

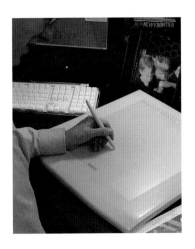

I highly recommend WACOM brand graphic tablets. I use the medium-sized one, but several top colorists prefer the smaller one. Everyone agrees that there's no need to buy the largest size.

GETTING YOUR WORK TO THE PUBLISHER

Although computer technology seems to change every four minutes, the storage medium for electronic files seems to have settled. In the past few years, floppy discs were replaced by Syquest disks, which were replaced by Zip disks. The most widely accepted way to get your files to the publisher today is via CD. Many new computers have built-in CD burners, and external CD burners have become very inexpensive. At a cost of about fifty cents per disk, CDs are incredibly cheap and very durable.

The only thing likely to take the place of CDs for data transfer is the FTP (File Transfer Protocol) site. Most of the major publishers across the country (comic book as well as magazine and book publishers) have their own FTP Web sites. This allows you to download black-and-white scanned pages and then upload your completed, colored pages for the company to retrieve. Not only is this process pretty much instantaneous, but it also saves on shipping costs.

Nevertheless, it's still a good thing to have a CD burner. All professional colorists archive their completed work, keeping a copy of each job on CD. Because things get lost in the mail and computer systems crash, it is wise to save a copy of your hard work.

SCANNING

If you're a freelance computer colorist who works for one of the major comic book companies, you won't be expected to scan the artwork you're going to color. Companies like DC scan all of the black-and-white original artwork and send it to the colorist on a CD or upload it onto an FTP site for the colorist to retrieve. Not only does this save the time it would take you to scan the pages, but it also allows DC to monitor the quality of the scans. Another advantage is it allows DC to keep the original art in-house, so the colorist won't be financially liable for loss or damage.

Of course, it's a great idea for you to have a good scanner anyway, in case you want to do work for a smaller company or if you choose to do work outside of the comics industry. If you want to scan and color your own work, you'll have that option.

Every company has different technical specs and requirements. Always ask the company that you're working for if they can supply you with their technical requirements. Most have a spec sheet that they can email to you.

In scanning, the rule of thumb is the higher the dpi (dots per inch), the sharper your image will be. Of course, the higher you go, the larger your final files are going to be, so don't get too high. Unless you've got a super-computer, any files over 100 megabytes are going to take a long time to work on and save. Your average page size (in its final, colored state) will probably be between 40 and 60 megs.

Some smaller companies use printers that will put your final colored files through a printing software (called a RIP program) that lowers all files to 300 dpi before they go on press, so always know what the publisher is looking for.

DC scans the 11″ x 17″ original black-and-white art pages at 450 dpi. This way, when they are printed at the smaller 6 3/4″ x 10 1/4″ comic book size, the resolution appears to look even sharper.

You could reduce the original page size down to printed size at the scanning stage and then scan at a higher dpi, but I've found that this creates a slightly lower-quality line.

An important note: If you're scanning black-and-white linework art yourself, make sure that you scan it as a Bitmap mode file (also called Text or Line Art or Black-and-White Drawing file on some scanners). This ensures that you get a pure black-and-white image, not a graytone one. Also, if during the scanning process you're given the option of scanning in anti-aliased mode, be sure *not* to choose it. I'll explain more about the anti-alias option in the next section of this book.

CMYK VS. RGB

When coloring comics (or anything else for that matter) in Photoshop, you have the opportunity to choose which mode you want to work in. For linework images that are black and white, select the BITMAP mode. If it's a tonal image of black, white, and grays, GRAYSCALE is best. If you're creating color images that will eventually be viewed on a computer monitor (such as web design, video games, or computer screen presentations), RGB is the correct mode. And for what we're doing, creating images for publication, CMYK is the most appropriate mode to use.

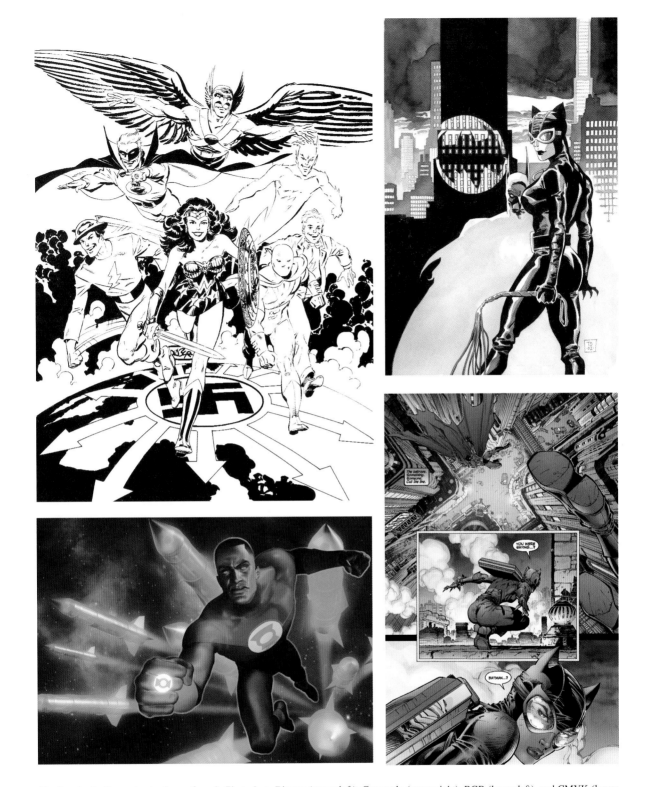

The four basic file modes to choose from in Photoshop: Bitmap (upper left), Grayscale (upper right), RGB (lower left), and CMYK (lower right). *Clockwise from top left:* From *Wonder Woman* #131 (March 1998). Pencils and inks: John Byrne. From *Detective Comics* #780 (May 2003). Pencils and inks: Tim Sale. From *Batman: Hush* (2003). Script: Jeph Loeb. Pencils: Jim Lee. Inks: Scott Williams. Colors: Alex Sinclair. Green Lantern art by Michael Striebling.

CMYK stands for Cyan, Magenta, Yellow, and black, the four printer's ink colors used in the standard printing process. The letter *K* is used instead of B to identify Black to avoid the confusion that B refers to blue.

Because RGB files are smaller in size than CMYK ones (they're smaller because RGB files have one less channel), some colorists prefer to work in that mode and then convert the files over to CMYK before shipping them to their publisher. (Remember, all publishers accept only CMYK files.) I have found that this isn't a wise thing to do for a few important reasons.

First, when you convert the files, the computer translates your RGB colors into the closest CMYK colors it can find. Most of the time, these colors end up having a small percentage of black ink in them. When printed, this will give your colors and the overall page a subtle, slightly dirty, or murky look (especially on yellow colors, which appear slightly greenish when low levels of black ink are added to them). This color shift can be even more of an unpleasant surprise when printed on many grades of comic book paper, which have a slightly grayish tone.

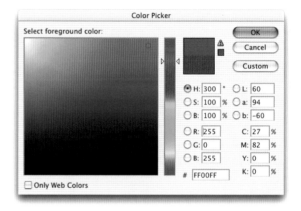

Since the RGB mode is primarily used to display images on a monitor, many of its colors are simply not reproducible on the printed page. When picking a "non-reproducible" RGB color, a gamut alert warning will appear in either the Color Picker or the Color Slider. It will show you what the chosen RGB color looks like, and also how it will actually print, usually in a much duller, deeper color.

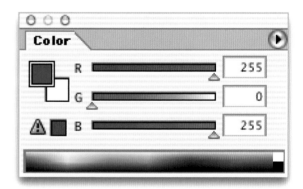

Another reason to work in CMYK mode is it's easier to understand the principles of CMYK than those of RGB. A printing press adds different percentages of cyan, magenta, yellow, and black inks onto white paper. When picking colors in the CMYK mode on your computer, you're doing relatively the same thing, adding different percentages of cyan, magenta, yellow, and black together to form colors. We can all easily understand how this type of color mixing works, because we all played with Play Doh when we were kids; if you added red clay with yellow clay, you got orange clay.

The RGB spectrum, on the other hand, is based on combinations of transparent light. RGB defines colors in terms of *relative* amounts of red, green, and blue. Black is equal to zero amount of these colors and white is equal to the maximum amount of these colors. I have to admit, after 25 years as a professional artist, I still can't figure that out!

A third reason to avoid working in RGB is a personal crusade of mine. There are certain aspects of comic books that are distinctive to the medium, including word balloons, speed lines, zip-a-tone dots, even people flying around! These have all combined to form this kooky medium that we love so much. On a somewhat more subtle level, the percentages of color in a comic book should be based on traditional comic book color percentages. For forty-plus years, comic book color choices were locked into choices of 25 percent increments. The standard comic book color chart was made up of 25, 50, 75, and 100 percent increments of cyan, magenta, and yellow. This gave comic books a specific look. When the computer was introduced, colorists started availing themselves of the literally *millions* of colors that the computer offered. Comics started to take on a look that was occasionally stunning, but more often the coloring appeared murky and over-rendered. Ah, the pitfalls of technology!

The colors that a computer colorist starts out with should be based on the traditional 124-color comic chart (which is based on adding together cyan, magenta, and yellow inks). Now, don't go screaming into the streets, thinking that I want to go back to the look of 1950's comics. I'm suggesting that those colors (referred to as primary book colors) should be your starting point, your base from which to deviate. Start with colors like comic book red (100 percent Y, 100 percent M) or comic book Caucasian skin color (25 percent Y, 25 percent M) and then once you've got them down, vary them a little. Maybe you'll decide to change that skin color to 20 percent Y, 15 percent M. You'll be bringing infinite options and creativity to your coloring, but still be working in the language of the medium.

FILE FORMAT

Most publishers will want you to save your colored pages as TIFF files. Although there are about 18 different types of file formats (TIFF, JPEG, PICT, Photoshop EPS, etc.), TIFF files are most widely required by comic book publishers. TIFF files are used to exchange files between applications and computer platforms and can be compressed (to save space) without loss of quality.

When saving a file, Photoshop will ask you if you want to compress the file using LZW Compression. Since this process will save and store your file at about 1/4 its size without any loss in quality, your answer should be *yes*!

SETTING UP YOUR DESKTOP

Photoshop allows you to show a whole bunch of information boxes on your screen at the same time. The question arises of how many palettes should be visible? Since your screen is only so big, you've got to decide what you want to show and what you want to hide. Some people actually work with two monitors at the same time, keeping all of their palettes and info boxes on the extra one. Since I can't afford to do that, I'll explain what I keep visible on my screen and why, then you should make your own choices.

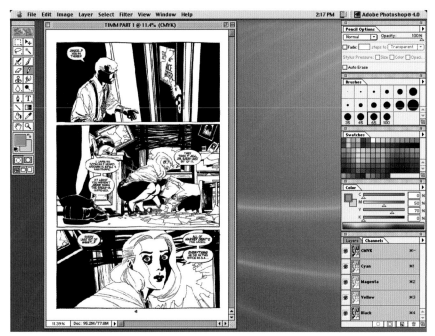

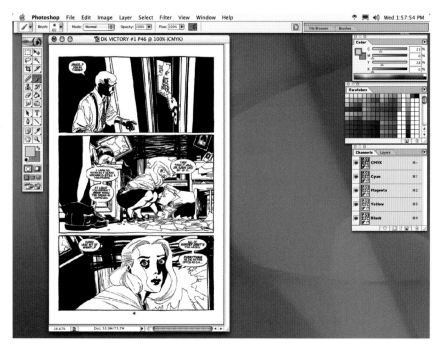

Top: This is a basic palette setup for early versions of Photoshop—in this case, version 4.0. *Bottom:* Because of the streamlined menu strip in more recent versions of Photoshop (version 7.0 shown here), palette boxes such as Options and Brushes can be hidden. This leaves more screen area for the image you're coloring. From *Batman: Dark Victory* (2001). Script: Jeph Loeb. Pencils and inks: Tim Sale. Colors: Gregory Wright.

All of the following boxes may be opened by pulling down the Window menu:

TOOLBOX

This is an absolute must. This is "command central" for Photoshop. I always keep it on the far-left side of the screen. Some colorists prefer to keep it on the right side, along with all of their other info boxes.

By double clicking on a specific tool, the Option box will appear. Since advanced coloring requires accessibility to many of the features in this control box, you'll want to have it visible. If you're using Photoshop version 7 or higher, the OPTION box is built into the menu strip at the top of the screen.

BRUSHES

When using the Pencil, Brush, Airbrush, and Eraser tools, you'll constantly be changing the size of each tool. This box shows the size of the current tool and all of the other sizes available to you. With newer versions of Photoshop, the Brush box is now a pulldown menu that is always present at the top of your Photoshop screen.

SWATCHES

This shows the colors available to you. You can use the default Photoshop palette that appears when you open Photoshop or set which palette you wish to use. This is done by pulling down the small triangle in the corner of the Swatches box and selecting Load Swatches. You can access them in the application Photoshop, in the Goodies folder, and under Color Swatches. Like most other comic book colorists, I've created my own customized palette, which I've loaded into Photoshop. It's based on the old, traditional DC color chart that's reproduced on page 12. The reason I like using this palette is, I'm so familiar with all of these colors from years of use, I feel completely comfortable with it.

Be careful about some palettes that are set up for both RGB *and* CMYK colors, since many RGB colors will look much brighter on screen than they will on the printed page. You can identify those RGB-only colors by the gamut warning sign, which also shows the color you've chosen and how it will actually print. Personally, I've chosen not to deal with this at all by using a palette made up of only CMYK colors. This way, what I see is what I get.

COLOR

This is also known as the Sliders box. I find this to be an invaluable info box. I can create and mix any color I want simply by moving the CMYK bars to the left or right. I can also glance over whenever I need to know exactly what percentages of color I've chosen. Remember, set it for CMYK sliders, not RGB sliders!

CHANNELS/PATHS/LAYERS

I always keep this info box open to Channels and just switch it over to Layers when I need to create or delete layers. I never use the Paths options.

It seems that just about every computer colorist sets up their files differently. As long as you're working in a manner that's okay with the company you're coloring for, your final files should be fine. It's always best to check with your editor or the company's production department before you begin working.

Of the many ways one can color using Photoshop, the following is the method preferred by DC Comics. Based on my many years working for both DC and Marvel, I find it to be the easiest and most logical system for creating clean, workable files.

Basically, you'll be creating a duplicate black channel, coloring the page and then pasting that black channel back on top of the coloring. Here's the step-by-step way to do it.

Before you start: You need to turn off the anti-aliased settings in all of the Photoshop tools that allow you to do so. They're slightly different in each version of Photoshop, so you might want to look through each tool just to make sure you haven't missed one. Here they are for Version 7:

- ELLIPTICAL MARQUEE TOOL
- LASSO TOOL
- MAGIC WAND TOOL
- PAINT BUCKET TOOL

You do this by simply double clicking on each of these tool icons and making sure that the little box next to anti-aliased is *not* checked.

The reason you do this is that if you use any tool with anti-aliased selected, the linework of your artwork will turn slightly blurry during the set-up and/or clean-up stages. It's difficult to go back into your completed colored pages and make any sort of corrections when the linework is blurry.

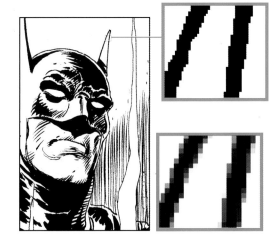

These extreme close-ups of the linework of Batman's ear shows a non anti-aliased line (top box) and an anti-aliased version of the same line (bottom box). From *Batman: Black and White* (1996). Pencils and inks: Joe Kubert.

STEP 1: SETTING UP YOUR FILES

OK, so you've received your bitmap scans from DC (or you've scanned them yourself). Open up one of the pages in Photoshop. Since you'll be working in CMYK mode (not RGB), you've got to do the following: In the pulldown Image menu at the top of your screen, go into mode and switch the file from Bitmap to Grayscale. (A little dialogue box will pop up. Make sure the size ratio is set at 1, and then click OK.) Go back into Image and then mode again, and this time change the Grayscale mode to CMYK.

Now, go over to your Channels box and click on the Black channel. You'll notice that only the Black channel stays active, and the others become inactive. Hold down the little triangle in the upper right-hand corner of the Channels box, and select Duplicate Channel. Another dialogue box will pop up, that shows your computer is naming this new channel Black Copy. Click OK. Click on the CMYK channel and all of the channels will become active again, *except* for your new Black Copy channel.

Make sure the eyeball icon in front of each channel is on, including the one in front of your new Black Copy channel. This channel should stay inactive, but you'll always want to be able to see it.

Select all (Command A) and then fill the entire page with white (Edit, Fill). This will get rid of all of the color that's sitting directly underneath your new black copy. You need to do this at this stage so it won't interfere with the clean-up step you'll do later in this process. *Save your file.*

Time out for a second! At this point, you need to check three settings in your version of Photoshop. Once you check them and make any necessary changes, you'll never have to do this again (unless you buy a new computer or get a new version of Photoshop).

Double click your new Black Copy channel and look at the Channel Options box that pops up. If Selected Areas is checked and if the little color square towards the bottom is black and set at 100 percent, then your settings are already correct and you can skip over the rest of these instructions.

If they're set differently, you have to do the following:

If Masked Areas or Spot Color is selected, change it to Selected Areas. Down below, type in 100 percent for Opacity. Now, double click on the color square that's next to the opacity setting. You'll get the Color Picker box. In the lower right-hand corner of that box, change the settings to C: 0 percent, M: 0 percent, Y: 0 percent, K: 100 percent. Hit OK. Hit OK again to get out of the Channel Options box.

This next part might sound weird, but do it anyway: Go into File at the top of the screen and select Save As. In the box that comes up, under Save As, type in the name JUNK COPY. Next, in the Format space, pick TIFF. Finally, in Where, make sure Desktop is selected. Hit Save and then OK.

You'll notice that the file (called JUNK COPY) has been saved to your desktop. Throw it out. That's right, drag it over to your garbage pail and then go up to Finder and select Empty Trash. Doing all of this strange stuff is the only way to correctly set your Channel Preferences settings for all Photoshop files you create from this point on.

Unfortunately, you now have to open up the bitmap file that you originally started with and start over again at Step 1: Setting up Your Files. The next time you arrive at this section, just skip over it and continue at the very next paragraph.

When you're ready to proceed and set up your file again, check to see if your Black Copy has turned slightly gray. If so, refer to the instruction box below in Step 2: Applying Color.

You have just set up your page, which is now prepped and ready to be colored. If you've done everything correctly so far, when you turn off the eyeball in front of the Black Copy channel, the page should look completely white.

Let me take a moment to explain why you created a duplicate black channel. While coloring your page, it's inevitable that you'll mistakenly color over some of the original black linework. Since you've planned ahead and created a duplicate of that black linework, all you'll need to do (once you've finished putting down all of your colors) is place the duplicate back into the original black channel. I explain exactly how to do this in Step 3: Cleaning Up Your Files.

Now you're ready to turn your CMYK channels back on and start coloring

STEP 2: APPLYING COLOR

One quick note about something that you may encounter during the coloring stage: If you're using one of the newer versions of Photoshop (version 6, 7, or 8), you may notice something odd about the black copy that you've created. If you color over an area that has blackline in it, it will appear that some of the color will alter the blackline and make it not look like pure black anymore. This can be a bit frustrating and bothersome, but there's a short step you can do to rectify this problem:

Click on your Black Copy channel, which will select it and turn off all of the other channels (but all of the eyeballs should stay *on*).

In the pulldown Image menu at the top of your screen, go into Adjustments and then Levels. In the first Input Levels box that appears, type in the number 25. You'll notice that the little black triangle below has moved over to the right a bit. You'll also notice that you've solved the problem and your copy of the Black Line has turned fully black again. Hit OK and then click on the CMYK channel, which will turn all of your channels back on and turn your Black Copy channel back off. *Save* your file.

I'm going to temporarily skip the all-important process of applying color (the *fun* part!), because I want to get the technical stuff out of the way. Once you put down all of your colors (discussed in great detail starting on page 54, you'll need to do the following…

STEP 3: CLEANING UP YOUR FILES

Here's one important final set of steps you need to go through *after you've finished all of your coloring*.

Because of the way I had you set up your files, you have an extra, untouched black copy channel. Again, this was important to create because during the coloring process, you most likely colored over and on top of much of your black channel. Now, you need to paste the black copy channel back over the C, M, Y, and K channels. Here's how you do it:

Go up to the Select menu and pull down Load Selection. In the dialogue box that pops up, Black Copy should be selected. Hit OK. You'll see that all of your black linework is selected. Here's where it gets a little confusing, but just follow these steps and I'll explain later why you did it this way.

Under Select, pull down Modify and then Contract. Type in the number 2. This will make your blackline copy selection smaller all around by two pixels. Hit OK.

Select the color 60 percent C, 40 percent M, 40 percent Y (from the Color Sliders box). Pull down Edit then Fill. Opacity should be 100 percent, mode should be Normal. Hit OK.

If you were to turn off the Black Copy eyeball, you'd notice that all the art that should be black is now gray. This gray is called your undercolor.

Select your Black Copy again (Select/Load Selection/OK). Now, fill this selection with 100 percent K (Edit/Fill/Multiply). Make sure you fill it at Multiply this time, *not* at Normal. This will put a layer of flat black ink over your undercolor.

Delete your extra Black Copy channel (by clicking on the Black Copy channel, going up to the little black triangle in the upper righthand corner of the channels box, and selecting Delete Channel).

Save!

If you've done everything right, you should now have five channels (CMYK, cyan, magenta, yellow, and black). To check, click off the eyeball for the Black channel, which will make that channel invisible. You should be able to see the gray undercolor beneath all of the areas that will print as black. If you zoom way in to look at the gray undercolor, you'll notice that it's actually slightly smaller than the black linework. Also, your color should butt up right against your gray undercolor.

OK, so why did you have to create a gray undercolor? If you had simply put down your 100 percent black linework over your CMY coloring job, the black areas would look weak, and not print as a true, rich black. By adding a mixture of cyan, magenta, and yellow ink under the 100 percent black, you end up with a deep, rich black, called a four-color black. The other reason is that this process cleans up any stray color that you may have put down underneath the black areas during the coloring stage.

Why did you have to contract the undercolor by two pixels? If your undercolor was *exactly* directly under every pixel of

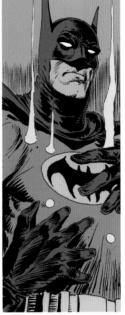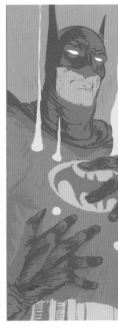

This example shows a normally colored panel and then the same panel with its black linework removed. This has been done to show you that underneath every black line there should be a gray mixture of color. By setting up your files with this gray "undercolor," all of your black linework will print as a rich, deep black. Art: Joe Kubert.

These two versions of the same panel show the benefit of placing a gray undercolor beneath your black linework. In the first version, you'll notice that the gray undercolor has created a bold, rich black. The second version shows how placing no color underneath black areas creates a much duller, less vibrant black. Script: Jeph Loeb. Art: Tim Sale.

black ink, you obviously wouldn't be able to see it (which is good). But if the black plate shifted even the tiniest bit while on press, you'd see some of that undercolor (which is bad). As good as today's professional printers are, there's just no way for the line-up of colors and black ink to be 100 percent perfect.

Here's a suggestion for all of you advanced colorists out there: The above process of setting up and cleaning up your files can be automated by using the *actions* feature in Photoshop. By assigning a function key on your keyboard for *setting up files* and another key for *cleaning up files*, you'll be able to perform the entire series of steps simply by hitting each of these two keys. This is a great time saver, especially when you're coloring an entire book. For the specifics on how to set up action keys, refer to your Photoshop manual.

Incorrect trapping of the gray undercolor can result in this out of register 'halo' effect. If you follow my instructions for contracting the undercolor by two pixels, this won't occur.

STEP 4: COLORHOLDS AND FILTERS

COLORHOLDS

When you're all done coloring your files and cleaning them up, you may choose to go back in and add colors to some of your linework. Here's how you do this:

Turn on only your Black channel and click on any area of black with the Magic Wand tool (set at a tolerance of 2 and with the contiguous box *not* checked). All of your black linework will be selected. Click back on the CMYK channel, which will turn all of the channels (including Black) back on.

Now, using the Pencil tool, and any color other than black, you can change selected areas of the blackline to a color simply by drawing your chosen color over the black areas you want to alter. This takes a little practice, but after a while, you'll be a pro at colorizing exactly which linework you want to. This is great for colorizing the linework around flames or energy bolts. When you're done, *save* your file.

A word to the wise: Knowing how to colorize linework is important, but knowing *when* to is equally, if not more, important. Like many Photoshop special-effect techniques, colorholds can easily be overdone and become gimmicky. But, more on that later.

From *Just Imagine Stan Lee's Secret Files*. Art: Dave Gibbons.

As with all filter use, subtlety is the key. Here, a non-obtrusive water ripple effect adds to the illustration without becoming the inappropriate focus of the panel. From *Superman: The Man of Steel* #97 (February 2000). Script: Mark Schultz. Pencils: Doug Mahnke. Inks: Tom Nguyen. Colors: WildStorm FX.

FILTERS

If you want to add lens flares or any other type of special effects to your page, now is the time. Since some of Photoshop's filters work only on RGB files, you'll have to turn your CMYK files over to RGB mode (Pull down Image, Mode, and then change to RGB). You can now add digital effects to your page by choosing one from the pulldown Filter menu at the top of the screen. When you're all done, change the page back into CMYK mode and *save*.

One last note, you might want to save an extra copy of your page and put it aside *before* you add any special filter effects, just in case your editor doesn't like them. It's a lot easier to resend the effect-free page than it is to remove lens flares and motion blurs from a completed file.

Your files are now completely done and can be sent to the publisher.

FLATS

Now you're ready to start the actual coloring part of the job. The first step is setting up what are called flats. Flats can be easily defined as the simple, basic shapes of color on your page.

By using the Lasso or Marquee tool, select each panel and fill it with a color (Edit/Fill). Remember to leave the gutters (the space between and around the panels) white. Don't worry about the word balloons at this point.

Save your work every time you think of it. Between steps, before you get up to go to the bathroom, after you've finished modeling a head. ALWAYS BE SAVING!

Now, beginning with the largest areas, start selecting and filling the different elements of the picture. Most colorists work on one panel at a time, but it's OK to jump around the page and color whatever you want. Use colors that are in the general ballpark of how you picture the final page to look without modeling. These colors are referred to as "base" colors. It'll probably be easier for you to "flat" some of the smaller objects using the Pencil tool.

 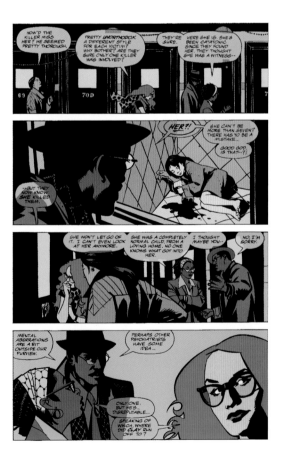

Lasso vs. *Paint Bucket* vs. *Pencil*: Which tool should you use? Although the Paint Bucket tool is fun and fast, it has a major drawback. When you use the Paint Bucket tool, it fills in the white spaces with color and stops when it touches any black linework. This may look perfectly fine, but for professional reproduction needs, that's simply not good enough.

There are three basic steps for creating flats. First, fill each panel with a flat color. Next, fill each major shape with different flat colors. Don't worry if you color over the word balloons at this stage, because lastly, you will be coloring all of the balloons white. From *Challengers of the Unknown* #1 (February 1997). Pencils: John Paul Leon. Inks: Shawn Martinbrough. Colors: Matt Hollingsworth.

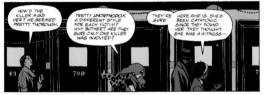

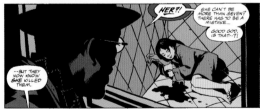

Lastly, using the Lasso or Pencil tool, select and fill all of the word balloons with white.

It's important that your color actually goes a little farther underneath the black areas (in printer's terms, this is called a *spread*). The reason for this is if any of the printing plates shift slightly during the high-speed printing process (which is bound to happen), you'll need a little extra color underneath the edges of the black to stop any of the white paper from peeking out.

If you use the Lasso tool to select large areas, you'll naturally be adding a bit of your color underneath some of the black areas. This is exactly what you want! Once you finish all of the application of color and then do the final few steps for preparing your files, as explained on page 51, everything will be perfectly ready for reproduction.

Along with the wonderful Lasso tool, you can use the Pencil tool to correctly put down color. I like to use the Lasso tool to color large areas and the Pencil tool for smaller ones.

When you're all done flatting the entire page, it will probably look like an old, traditionally colored comic page. Unless you've picked wacky, far-out colors for your flats, the page should have a pleasing overall color scheme. The colors you've chosen are called your base colors. See the box on the next page for an explanation of base colors

At this point, many colorists create a *flats channel*. This is done in a few easy steps: First, Select all (command-A) and Copy it (command-C). Next, create a new channel and call it Flats (done by pulling down the little triangle in the upper righthand corner of the channel box and selecting New Channel). Lastly, Paste your selection right into this new channel (command-V). You'll see your image reproduced as graytones in your new Flats channel. Save. Now, you'll always be able to select a flatted shape, even later, after you've done all of your rendering (this is great for doing corrections later).

In the next stage of coloring (modeling), you'll need to select your individual flat shapes one at a time. You can easily use the Magic Wand tool to do this. For this, keep your Magic Wand Tolerance Level at a low setting, like 2. (The higher you set Tolerance Level, the more colors it will select.) Now, simply click on any flat color area and only that area will be selected.

When using Photoshop, don't expect to do *everything* just by using the tablet pen (or mouse). You should use the graphics tablet pen (or mouse) *and* the keyboard in combination. That way, you will be able to speed your work along by learning keystroke shortcuts. If you watch a really good colorist work, his drawing hand is constantly in motion, drawing and tracing with the pen (or mouse), while his other hand is repeatedly punching away at their keyboard. Don't worry, you'll get used to it.

Here are a few of my favorite Mac shortcuts:

General Keystroke Shortcuts

D When you're all done with your selection, you'll have to de-select it. Hit Command and the D key at the same time.

S As I said earlier, *save* your work *every* time you think about it! Hit the Command and the S key at the same time to save.

Z If your last action doesn't look good or if you simply hit the wrong key, hit Command and the Z key at the same time to undo. Hit them again and your mistake comes right back.

OPTION/DELETE If you want to fill a selection very quickly, press the Option and Delete keys at the same time.

TAB KEY: If you want to hide all of your palettes and toolboxes, hit the Tab key and they'll all disappear. Hit Tab again and they'll reappear!

SPACE BAR No matter what tool is selected in Photoshop, if you hold down the Space Bar, that icon will turn into the Hand (Move tool) icon. While pressing down on the Space Bar, draw with your graphics pen (or click your mouse, as the case may be). Instead of drawing anything, you'll notice that you're moving your page around the screen.

HAND ICON If you're zooming into a portion of your image and you want to quickly zoom out to see the whole page again, double-click on the Hand icon. Easy!

ZOOM (or MAGNIFYING GLASS) ICON If you want to zoom in on a specific portion of the image, let's say an eyeball, hold down the Zoom tool and drag the box around the area you want. When you let go, you get a close-up view of the eyeball.

A *base color* is the truest basic color of an object, without highlights or shadows affecting that object. For example, the base color of a lemon is pure, bright yellow (100 percent yellow). The base color of Superman's cape is bright red (100 percent yellow, 100 percent magenta). The base color of a person's shirt is whatever *one* color you decide it should be.

Of all the Photoshop tools, the Lasso is the most important. Sure, you'll have to become really good with the Pencil, Airbrush, and Grad tools, but the Lasso is the real focal point of computer coloring. Master it, and you'll master the world!

Play around and practice with it a bit. Once you're used to it, you'll be able to trace around almost any shape in a few seconds.

Here are some handy keystroke shortcuts to use with the Lasso tool:

Lasso Keystroke Shortcuts

 H If you've made a selection using the Lasso tool, hit Command and the H key at the same time. This will hide the border of your selection (that moving border is often lovingly referred to as "marching ants"). It's still there; you just can't see it. Hit the same two keys again and they come back. This is a great way to get those distracting marching ants out of your way while you fill or render the selected area.

Once you're done filling, don't forget to de-select the selection.

 SHIFT KEY Let's say you trace a selection around Superman's head with the Lasso tool, but you also want to select his hands. You'll notice that if you start tracing with the Lasso tool around a hand, your previous head selection will disappear. By keeping your finger down on the Shift key while you trace the hands, you can add more selections to your original one.

 OPTION KEY Let's say you trace around Superman's head, but don't want his eyes to be part of the selection. Simply hold down the Option key while you trace around the eyes to deselect them.

This is also great to use if your tracing is a bit sloppy and you want to remove little areas that you didn't mean to select.

 COMMAND KEY When you draw with the Lasso tool, you get an uneven, free-form line. If you want perfectly straight, uniform lines (and selections), hold down the Command key and click the Lasso tool from point to point. This is a great tip for tracing around straight things like buildings and windows or for adding linear, hard-edged modeling to figures and forms.

Many of the best computer colorists use this technique to do the majority of their tracing. You'll be amazed at how fast you can get working this way as you zip around contours, grabbing large chunks of the object you're selecting. *Practice this one as much as humanly possible.*

By adding shadows and highlights to each flatted shape, you can model (or render) as much or as little as you like. Here's where you add depth and dimensionality, giving two-dimensional images the illusion of three dimensions. Along with shadows and highlights, you'll be adding light sources, textures, drama and atmosphere.

This step in the creation of a comic represents the biggest change that's ever been made in the art of the comic book. Where once comic book coloring was a technical process with very few options, it is now one of limitless possibilities. Many of today's comics look more like classically illustrated storybooks than the disposable comic books of the past. This is due primarily to the role of the computer colorist. Always remember, though, that there's a fine line between lush, beautifully rendered coloring and over-done, grotesquely outrageous coloring. The choice of which kind you produce is up to you.

Some colorists render the main figure first, followed by the secondary objects (cars, other people in the panel, etc.), and lastly the background (buildings, planets, mountains). This is because their interest and energy level are at their highest when they first start a new panel. By using this approach, the most important stuff in the panel gets the most attention.

Other colorists choose to work background to foreground. The background buildings first, then the background people, then the main foreground figure. This approach is known as stacking, because you're able to color through objects (you first color the *whole* building, regardless of what's in front of it. Then you color the objects that fall in front of the building). This is a faster way of rendering, so try both and decide what's more comfortable for you.

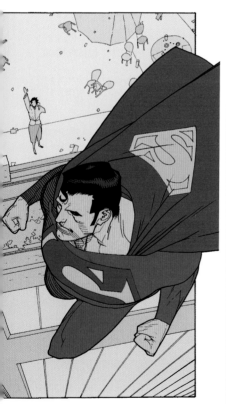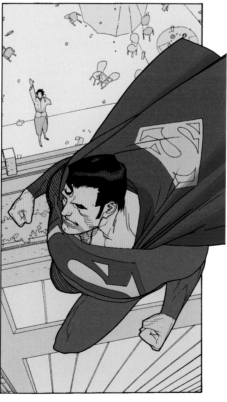

Here are the three steps for modeling each panel. Once you've put down your flat, base colors (panel #1), pick one specific area to work on. In this example, I've picked Superman's cape. Add your shadows (panel #2), making sure that you keep the lightsource consistent. Next, add the highlights (panel #3). When you're done with this step, you've got a fully rendered cape. After that, you can move on to another area of the panel and go through these steps again, until there's nothing left to render. From *Superman Birthright* #5 (2004). Pencils: Leinil Yu. Inks: Gerry Alanguilan.

No matter what object you're modeling, always remember to start with a flat base color, never with shadow or highlight colors. For example, if you're modeling Superman's cape, start with the cape's base color (100 percent yellow, 100 percent magenta). Then add a darker version of that color for your shadows (100 percent yellow, 100 percent magenta, 30 percent cyan). Then add a lighter version of the base color for your highlights (75 percent magenta, 65 percent yellow).

Here are the basic steps for modeling. You'll need to do this, to a varying degree, for each object in each panel:

Step 1: Apply flat (base) colors. (You've already done this step.)

Step 2: Put a simple gradient fill (grad) on an object or plane. See page 60 for the different types of grads.

Step 3: Add shadows. See page 61 for the different types.

Step 4: Add highlights. See page 62 for the different types.

LIGHT SOURCE

Before you start throwing in a whole bunch of shadows and highlights, take a moment to look at the artwork. Has the artist (penciller and inker) established his own light source? Good artists determine where the sun is shining or where the lights are in a room, and they keep these light sources consistent throughout the scene. It's your job to follow their lead and stay faithful to what was established.

Use the information given to you by the artist to determine the direction of the light source. In this example, the artist has indicated that the light comes from below and from the left. In the top panel, the colorist has acknowledged this and rendered the shadows and highlights to be in harmony with the drawing.

In the bottom panel however, the colorist has disregarded the artist's intent and put the light-source on the right-hand side. The result is an image that somehow feels wrong. From *Batman: Black and White* #1 (June 1996). Script and art: Bruce Timm.

Some artists choose to use very little black in their work and therefore rarely determine in which direction the light source is. In this case, the colorist should decide.

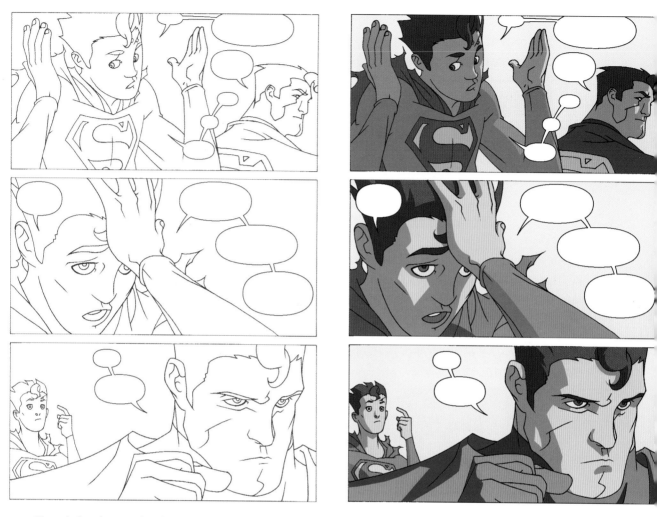

The artist has chosen to draw in a style that gives very little light source information to the colorist. When this happens, it's up to the colorist to place appropriate shadows and highlights. From *Superman Jr. & Superman Sr.* #1 (May 2000). Script: Karl Kesel. Pencils and inks: Rob Haynes. Colors: David Self.

GRADIENT FILLS
(ALSO KNOWN AS GRADS)

After you've put down simple, flat colors on each object (flats), you'll want to start setting up your basic light sources for many of those shapes. Starting with the base color you've already put down, use the grad tool (on the Foreground to Transparent setting) to emphasize the direction of the light source.

Working within the color range of the object, grad from one side of an object to the other. For a floor, you might want to grad from light gray to the dark gray base color that you have already flatted. On a face, you might choose to grad the yellowish light source from left to right, ending with your base skin color. In a sky, you might want to go from a light blue to a dark blue.

Putting in your grads is easy, quick, and fun. You should grad only the basic, large areas in each panel (floors, walls, skies, large areas of clothing, etc) and not concern yourself with smaller objects (hands, shoes, guns, etc).

Play around and experiment with the Grad tool for a while until you understand all of the different ways it can be used. The four most valuable types of grads are linear, radial, foreground-to-background and foreground-to-transparent grads.

SHADOWS

There are two basic types of shadows: cast shadows and form shadows. These are the building blocks used to correctly give your coloring dimensionality and volume, so *pay attention!*

Cast shadows are the hard-edged shadows that are created when an object blocks out the light falling onto another object. A good example is a flagpole: As it gets between the sun and the ground, it casts a shadow. A cast shadow is usually darkest closer to an object, and lighter the farther away from the object it gets. A cast shadow can fall on any object.

Above: Grads can add subtle lighting variations to any object or surface. Here, we start with the flat color of the water and the flat color of the wooden dock. Next, we add a darker color to the top of the water area by using a simple linear grad. Using a lighter wood color, a radial (circular) grad is applied to the dock in the spot where the light source would fall. Lastly, color is added to all the other objects and the word balloon. The result is a subtle, effective environment. From *Batman: Mad Love* (1994). Script: Paul Dini. Pencils and inks by Bruce Timm.

Form shadows are the softer, gradual shadows that define the curve of an object. The best example is a ball: The part of the ball that is farthest away from the light source is the darkest.

Most often, the artist will determine where shadows and highlights originate. From the direction of the shadows on the ground, it's obvious here that the light source is coming from the open door. From *Batman: Ego* (2000). Art: Darwyn Cooke.

When used in combination, you can create totally believable modeling on any object.

Once you become absolutely comfortable and proficient applying shadows, you'll want to investigate the other, more subtle types of shadows and highlights.

HIGHLIGHTS

The area of any object that receives the most reflected light is called the highlight. Look at your hand. Really, look down at your hand and note where the light and shadows fall. Within the light area of your hand, there should be an even lighter area, called the highlight. It's tough to see on your skin because flesh isn't nearly as reflective as metal or plastic or any other shiny surface. But look at your fingernails: Because they have a harder, more reflective surface, you should be able to see the highlight right away.

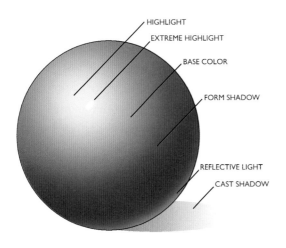

To be a good colorist, you'll have to train your eye to (a) understand the patterns that highlights make on objects, and (b) note how light reflects differently on different surfaces. Obviously, cloth reflects less light than wood does, but different types of cloth have different types of highlights, too.

Highlights on modern super hero costumes are usually fairly shiny and reflective. From *Superman* #181 (June 2002), Script: Jeph Loeb. Pencils: Ed McGuinness. Inks: Cam Smith. Colors: Tanya & Rich Horie. From *Superman* #168 (May 2001). Pencils: Ed McGuinness. Inks: Cam Smith. Colors: Tanya and Rich Horie.

SECONDARY LIGHT SOURCES

One aspect of computer comic book coloring that sets it apart from traditional coloring is the practice of adding secondary or reflective light to objects. If you've modeled a panel (or scene) and you feel the characters look a bit flat, you can pop them by adding a secondary light source.

The shinier and harder the surface, the whiter and more hard-edged the highlight should be. The duller and softer the surface, the closer the highlights are to the object's base color, and the more soft-edged they are. This is a good rule-of-thumb.

Here's how you do it: Pick a bright color that's very different from the color of your main light source *and* the color of your background. Now, using that color, add highlights to one side of the objects in your panel. Be sure to be consistent about the direction your secondary light is coming from. It would be unnatural and weird-looking if you had reflective light coming from several different directions.

The real plus of adding secondary light is it allows you to retain the overall color scheme of a scene, and at the same time define (or pop) the characters.

Beware! When people first started using computers to color comics, the practice of adding secondary light sources was overdone to such a degree that it became a visual joke. Some computer colorists started adding second and third and fourth light sources

Here, warm rim lighting defines the shape of a character. This technique works well in cases where the character and background colors are similar. From *Danger Girl* #6. Pencils and inks: J. Scott Campbell. Colors: Justin Ponsor. From *Flinch* #1 (June 1999). Text: Richard Bruning. Pencils and inks: Jim Lee. Colors: Tad Ehrlich.

to every object on the page. The result was a glitzy, but confusing, visual mess. It defeated the prime directive of coloring: to aid in telling the story.

SKIN TONES

You're probably going to say that a section devoted exclusively to skin tones and skin color is a bit excessive. You'd be right if they weren't so frequently mishandled, even by good colorists. Since the human (and sometimes inhuman) face and hands are consistently focal points in comic book story-telling, it's important to avoid some of the pitfalls that computer colorists fall into.

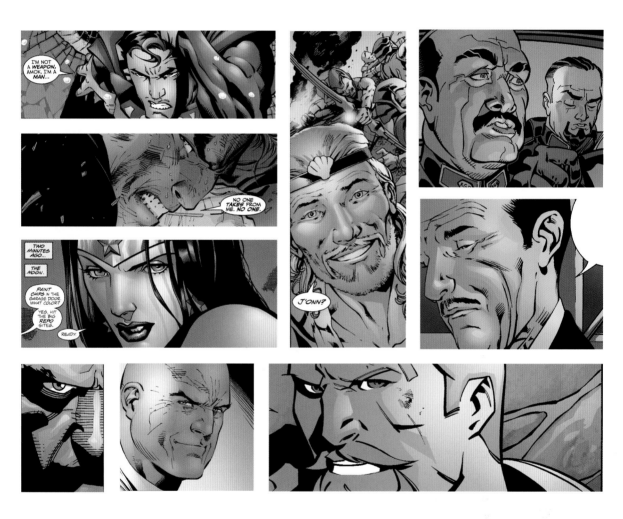

The most important and most difficult job of a comic book colorist is possibly the coloring and rendering of the face. Whatever style you choose to color in, your skin tones must have a natural, realistic look, without being over-done. Here are several varied examples that show confident, well-thought-out approaches to coloring faces. Clockwise from upper left: From *Superman: The 10 Cent Adventure* (March 2003). Script: Steven Seagle. Pencils: Scott McDaniel. Inks: Andy Owens. Colors: Tanya & Rich Horie. From *JLA: Heaven's Ladder* (2000). Pencils: Bryan Hitch. Inks: Paul Neary. Colors: Laura Depuy. From *Superman: Red Son* (2004). Pencils: Dave Johnson. Inks: Walden Wong. Colors: Paul Mounts. From JLA: *Heaven's Ladder* (2000). Pencils: Bryan Hitch. Inks: Paul Neary. Colors: Laura Depuy. From *Green Arrow* #29 (October 2003). Pencils: Phil Hester. Inks: Ande Parks. Colors: Guy Major. From *Batman: Hush* (2003). Pencils: Jim Lee. Inks: Scott Williams. Colors: Alex Sinclair. From *Superman Birthright* #6 (March 2004). Pencils: Leinil Yu. Inks: Gerry Alanguilan. Colors: Dave McCaig. From *JLA* #61 (February 2002). Script: Joe Kelly. Pencils: Doug Mahnke. Inks: Tom Nguyen. Colors: David Baron. From *Batman: Hush* (2003). Script: Jeph Loeb. Pencils: Jim Lee, Inks: Scott Williams. Colors: Alex Sinclair.

Problem #1: Over-saturated skin tones

Simply put, this is when you use too much color on a face. For the average Caucasian face, a good base color is 20 percent yellow, 20 percent magenta. Once you put down your base skin color, you should add lighter colors for highlights and darker colors for shadows. Although there's a lot of variety to the many skin tones of black people, a good base color is 65 percent yellow, 60 percent magenta, 45 percent cyan.

Although you will certainly vary these base colors, you should probably stay somewhere in this general neighborhood as a starting point.

Problem #2: Overusing K tones in skin colors

Adding black ink (also known as K tones) to your skin tone color mix is a tricky thing. It tends to muddy up the overall look of the skin. I recommend avoiding it all together and mixing your skin colors only from combinations of magenta, yellow and cyan.

Problem #3: Uncertain light sources

It's your job to ascertain what light source the penciller and inker have set up for the scene you're coloring. Be faithful to it, and you'll complement their work perfectly. Ignore it, and you'll do a junky job.

Of course, there are times when the penciller/inker has decided to set up no apparent light source. In this situation, it's up to you to choose and render natural, logical, and consistent lighting.

Problem #4: Over-rendered female faces

As is the unfortunate trend with many computer color jobs, heavy modeling, too many light sources, and too many effects can simply ruin good artwork. Nowhere is this more noticeable than on the skin tones on female characters. Over-rendered female faces very often will look harsh and manly. When you render the face of a woman or child (whether you're the penciller, inker, or colorist), the general rule-of-thumb is less is more.

Here, Wonder Woman's face is rendered in a clean, not overdone style. The second panel shows the danger of over-rendering a female face, in which the result is harsh and unattractive. The third panel shows how using too much color on a face gives an oversaturated, unnatural look. Pencils: Doug Mahnke. Inks: Tom Nguyen.

SEVEN
COLORING STYLE

RENDERING STYLES

By practicing the four basic steps of coloring (flats, grads, shadows, and highlights) that I've outlined, you'll be able to color comics like the pros.

You'll also want to look closely at the different types of comic coloring that's being done today. Different types of art call for different types of coloring. Working with these four basic steps, you can use many of the different Photoshop tools to render in just about any style you can imagine. Below are examples of the more popular rendering styles being used in comics today.

FLAT COLORING

Flat coloring is great for retro comics and kids comics. This is what most people think of as the way comics used to look. Obviously, this is the easiest way to color since you're really just putting down flat colors with minimal grad work (usually just in backgrounds) with no shading or highlights.

From *Silver Age* #1 (July 2000). Art: Brian Bolland.

From *Batman: Dark Victory* (2001). Script: Jeph Loeb. Pencils: Tim Sale. Inks: Tim Sale. Colors: Gregory Wright.

A note about coloring children's comics that feature licensed characters: Because companies like DC often license established characters from other companies, it is imperative that the colorist closely follow the colors that have already been established for these characters. This is not a type of comic that calls for overly stylish or experimental coloring. In most cases, the editor of the comic can supply a model sheet of each licensed character to the colorist. *Always* follow it closely!

Comics that feature licensed characters have to reflect the colors set forth by the owner of these characters. Usually, style guide art is available for colorists to precisely match colors. From *Powerpuff Girls* #42 (November 2003). Script: Robbie Busch. Pencils: Ricardo Garcia Fuentes. Inks: Mike DeCarlo. Colors: Dave Tanguay.

CUT-EDGE

This is the same as flat coloring with the addition of flat, graphic shading and/or highlights. Using the Lasso tool to add hard-edged shading gives flat comics a little more style. Many independent comics are colored in this stylized fashion because, if done properly, a hip, underground look can be attained. When creating cut-edge modeling for most

At right and on the next page are three examples of cut-edge coloring. From *Batman: Gotham Adventures* #43 (December 2001). Text: Scott Peterson. Pencils: Tim Levins. Inks: Terry Beatty. Colors: Lee Loughridge.

modern comics, you'll have to create transitional "steps" between your basic flat shapes. This technique is the backbone of the majority of modern comic book coloring.

Above: The New Frontier. *Right: Bizarro* (2003). Pencils and inks: Matt Groening. Colors: Nathan Kane. *The New Frontier #2* (April 2004). Script and art: Darwyn Cooke. Colors: Dave Stewart.

A I R B R U S H

Not as popular as it once was, this look is accomplished primarily by using the Airbrush tool for rendering. It's easy to give objects a smooth, rounded look using this tool, but be careful, this can be overdone. Artwork that is colored exclusively in this manner has been disparagingly referred to as "van art." If you remember the paintings that were done on the sides of vans in the 1970s, you'll know exactly what this means.

Here are two examples of airbrush coloring. From *JLA #52* (May 2001). Script: Mark Waid. Pencils: Bryan Hitch. Inks: Paul Neary. Colors: Laura Depuy. From *Batman Adventures Holiday Special* (1995). Art: Bruce Timm.

This is great for most modern comics, especially super hero books. The majority of comic books are colored this way. By using a combination of the three key Photoshop tools (Lasso, Grad, and Airbrush), you can create absolutely breathtaking and believable modeling.

This is the preferred style of coloring for DC Comics, as well as the other major companies.

Here are three examples of cut-edge with grads and airbrush. *Top left:* From *Superman: The Man of Steel* #97 (February 2000). Script: Mark Schultz. Pencils: Doug Mahnke. Inks: Tom Nguyen. Colors: WildStorm FX. *Top right:* From *Green Arrow* #28 (September 2003). Pencils: Phil Hester. Inks: Ande Parks. Colors: Guy Major. *Left:* From *The Ray Annual* (1992). Pencils and inks: Art Nichols. Colors: John Cebollero.

Many people think that manga and anime comics are the same thing, or at least colored in the same manner. They are not. This complex slice of the comics world is much too multifaceted to cover in a few paragraphs. There are many different looks and approaches to coloring manga and anime comics, so if you're interested in coloring either, you'll have to do a bit of research.

The look of manga coloring replicates that of cell animation: figures are colored with flat, simple modeling, and backgrounds are usually rendered in a painterly fashion to emulate background key art. Modeling on foreground objects, especially skin tones, is usually kept to two or three flat values. Often, metal objects are rendered with a very detailed, dimensional look, using primarily the Airbrush tool. As manga- and anime-style comic books become more popular, being able to color in this fashion is a big plus.

Top Left: From *Death: At Death's Door* (2003). Art: Jill Thompson.

Left: From *Teen Titans Go!* #2 (February 2004). Script: J. Torres. Pencils: Todd Nauck. Inks: Lary Stucker. Colors: Brad Anderson.

Above: From *Batman: Hong Kong* (2003). Script: Doug Moench. Art: Tony Wong.

Occasionally, you'll want to give a comic the look of fully painted illustration. Although rather labor-intensive, this look can be attained by adapting the techniques of traditional oil, acrylic, or watercolor painting to the digital world. Because of the power and sophistication of Photoshop, you can create or replicate any painted technique.

The *basic* technique for creating a painted look is to set your drawing tool (Pencil or Brush) at an opacity much less than 100 percent. I usually set mine at 20 percent opacity and go over an area several times, building up the shadows with a dark color and creating highlights with a light color. Practice this technique, it can be quite effective.

Painted covers and pages created on a computer: (right) *Young Justice: Our Worlds at War* #1 (2001). Pencils and inks: Jae Lee. Colors: Jose Villarrubia. *Bottom left:* From *Flinch* #1 (June 1999). Script: Richard Bruning. Pencils and inks: Jim Lee. Colors: Tad Ehrlich. *Bottom right:* From *Fallen Angel* #3 (November 2003). Art: Brian Stelfreeze.

The intent and goal of a comic book cover is quite different than that of the interior of a comic. The job of every artist who works on the inside of a comic is to tell a story. On the other hand, a cover is a single image that's aim is purely to entice a fan to buy that comic. That may sound a bit blunt, but it's true. Unless your comic exhibits an eye-catching cover image, chances are pretty good that a prospective buyer will pass your comic by in favor of a more appealing, colorful, action-packed cover.

There are many techniques/tools/tricks you can use to color a cover in a way that will make it stand out from all of the other comics at the comic shop. Remember, the rules of storytelling that guide interior coloring don't really apply to cover coloring. You simply want to create as powerful and emotional and cool an image as possible. Because of this, you may choose to color the background of your cover in a bright, flat color. This graphic device tends to catch the buyer's eye more quickly than a cover that's over-colored and busy. Another direction to explore is coloring a cover with the sole intent of creating an extremely dramatic image through moody or extreme lighting. Covers also offer a great opportunity to present a character in an iconic or symbolic fashion.

These are just a few of the hundreds of ways to give your covers the impact needed to set them apart from all of the rest of the competition. Visit your local comic book shop and note which covers stand out and appeal to you, and which coloring techniques were used to accomplish these results.

Above: From *Wonder Woman* #184 (September 2002). Art: Adam Hughes. From *JLA* #67 (August 2002). Pencils: Doug Mahnke. Inks: Tom Nguyen. Colors: David Baron. *Left:* From *Detective Comics* #746 (July 2000). Art: Dave Johnson.

Clockwise from top: From *Vigilante* #3 (January 1996). Art: Mark Chiarello. From *Batman* #600 (April 2002). Pencils and inks: Scott McDaniel. Colors: Patrick Martin. From *Wonder Woman* #139 (November 1998). Art: Adam Hughes. From *Superman* #120 (February 1997). Pencils: Ron Frenz. Inks: Joe Rubenstein. Colors: Patrick Martin. From *Batman Beyond* #9 (July 2000). Pencils: Craig Rousseau. Inks: Terry Beatty. Colors: Lee Loughridge.

EIGHT
THE TRAPS OF
COMPUTER COLORING

Much of the criticism against computer coloring stems from the fact that you can do so many cool things with a program like Photoshop. Remember, just because you *can* do something doesn't mean you should. As great a tool as Photoshop is, a more valuable one is your own good taste and common sense. Remember, as someone once said, "With great power comes great responsibility."

EFFECTS TO AVOID

Here are some awfully fun things you can do with a computer that you probably shouldn't:

IMPORTING PHOTOGRAPHS

Let's say you want to scan a photograph of the moon and copy it into the sky of a page you're coloring. Because the dot pattern of the photo is different than the dot pattern of the comic book, they really won't look right together. Also, photography and graphic illustration have two distinctly different looks. You *could* run the moon photograph through a series of Photoshop filters to make it look a bit more graphic or more like a drawing as opposed to a photograph. In most cases, it'll still look like, well, like someone pasted a photograph into a comic book!

Some colorists will use a subtle lens flare two or three times in a whole years' worth of comics. Others will use two or three lens flares on every page of every comic they color. Because of the overuse and abuse of this special effect over the years, we're all a bit tired of seeing them. They've taken on a gimmicky, cliched look that most good colorists should avoid.

The same is true for blur filters, which end up looking like a visual trick instead of a storytelling device. Sure, they can be used tastefully and effectively, but only by really talented colorists.

Lens flares can be accessed by choosing the Render menu under the Filter pulldown menu. The variety of blur filters can be found in the Blur menu under the Filter pulldown menu.

FILTERS

There are filters that stretch and squash images, filters that make linework drawings look like watercolor paintings, filters that make objects look like they're wrapped in plastic or chrome, filters that can distort, displace, pinch, ripple, spherize, twirl, and emboss your drawings. Most weak colorists use them on a regular basis. Most good colorists rarely use them. Need I say more?

Opposite page: The hand-drawn moon (left) appears much more in style with the rest of this illustration than the photo of the moon that was pasted into the same image (right). The photo seems somewhat out of place, and draws attention away from the characters in the image. From *Batman: Hush* (2003). Pencils: Jim Lee. Inks: Scott Williams. Colors: Alex Sinclair.
Above: In many comics, lens flares and blur filters have taken the place of good, solid coloring. Many new colorists think that by adding these effects, they're creating cool, exciting images. What they're really doing is detracting from the art and the clarity of the story. From *Flash* #208 (May 2004). Pencils: Howard Porter. Inks: Livesay.

A color hold is when you change a selected area of the black linework into a color. This can be a very effective storytelling technique when coloring an explosion or fire or water or neon signs or energy crackles. But if you are tempted to turn the linework of everyday objects a different color simply because it'll look cool, *don't*! Refer back to page 52 for specific instructions for doing color holds on your computer.

Color holds can be a very valuable asset to your coloring, but only if you learn how and when to use them properly.

Color holds can sometimes be used quite effectively. In the left panel, the linework of a holographic globe of the earth is colorheld to impressive, appropriate results. From *Superman: Red Son* (2004). Script: Mark Millar. Pencils: Kilian Plunkett. Inks: Walden Wong. Colors: Paul Mounts. On the right is a more subtle use of color holds. The linework of the distant clouds and city skyline have been held, creating a unique "line-free" background. From *Batman: Dark Victory* (2001). Script: Jeph Loeb. Pencils and inks: Tim Sale. Colors: Gregory Wright.

Above: By holding the linework of multiple Flash images in a dark color, they appear less "real" than the central image of the Flash, which has retained its black linework. From *JLA: Rules of Engagement*. Script: Joe Kelly. Pencils: Duncan Rouleau. Inks: Aaron Sowd. Colors: David Baron.

Left: Color holds can be taken too far, detracting from the artwork. Here, every line has been held, creating a jumbled, confusing image. From *Batman: Gotham Central* #12 (December 2003). Pencils and inks: Michael Lark.

SPECIAL CARE WHEN ADDING SPECIAL EFFECTS

When you're done coloring a page, you might want to go back in one last time and give a special effect glow to an object or two. This can be done a number of ways, but the simplest method is to airbrush a light color right over your coloring *and* linework. Caution and care must be taken when doing this because by coloring over the finished artwork at this stage, you're actually obscuring some of the artist's linework. Again, remember to be logical about where you add glows and SFX: good places are extreme highlights on metal surfaces or at the center of explosions, laser blasts, or heat sources.

Two nice examples of special effects. From *JLA* #89 (December 2003). Pencils: Doug Mahnke. Inks: Tom Nguyen. Colors: David Baron. From *JLA* #50 (March 2001). Pencils: Doug Mahnke. Inks: Walden Wong. Colors: Laura DePuy.

THE PITFALLS OF CREATING TEXTURES

With Photoshop, you can add textures to just about any surface: stone or brick textures to walls, wood-grain texture to tables or floors, sand or concrete textures to sand or concrete.

This technique is usually overdone, drawing way too much attention to the background, and drawing interest away from what should be the focal point of the panel. The use of ridiculous, overdone background textures is always the first sign of a novice computer colorist. The option of using all of Photoshop's gimmicky filters and textures is usually too much fun for a new colorist to resist. In time, the better new colorists drift away from gimmicks and get down to the business of telling the story.

If you decide to use any textures at all, please do it in a subtle manner. A slight patterned texture on a living room rug is fine, but it shouldn't draw undue attention to the rug.

The most effective place to use textures is in the special effects. Blasts from the fingertips of supervillians can be made to look really cool by adding a warped, otherworldly pattern into the blast.

I'll repeat a note I made much earlier in the book: Since you're coloring in CMYK mode, you'll have to convert over to RGB mode to add certain filters to your page. It's easy to do, and should be done at the very end of the creative process. Just be sure to remember to convert your file back to CMYK mode when you're all done!

Opposite: The same page is printed on newsprint (left) and on whiter, more expensive paper stock (right). Note how the slight brown/gray tone of newsprint subtly dulls down all the colors on the page. From *Batman Adventures* #12 (May 2004). Script: Ty Templeton. Pencils: Rick Burchett. Inks: Terry Beatty. Colors: Lee Loughridge.

Very often, colorists who are new to the computer will be confused and frustrated as to why the image they've colored looks so good on their monitor and so awful on the printed page. Several factors can contribute to this problem: monitor calibration, paper stock, the conversion from RGB to CMYK, and using personal printers to create proofs.

MONITOR CALIBRATION

Regardless of the quality or size of your monitor, you absolutely need to calibrate it. You can do this a number of ways, the most direct and recommended way being through the software you are using (in this case, Photoshop). Here's what you need to do: In your Photoshop folder (which is probably in your Applications folder in your Hard Drive), there's a folder called Goodies. In that folder is another folder called Calibration. Inside that folder is a calibration panel called Gamma. All you need to do is follow the step-by-step instructions and you'll end up with a monitor that closely displays colors accurate to the actual colors you've chosen.

PAPER STOCK

When getting a new assignment, many top-notch professional colorists will ask their editor what type of paper stock the comic will be printed on. Because there are several different paper stocks being used

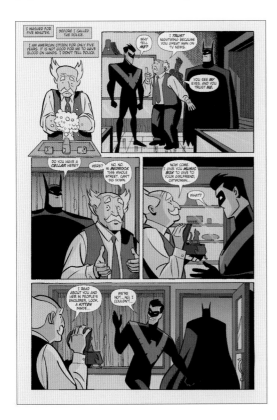
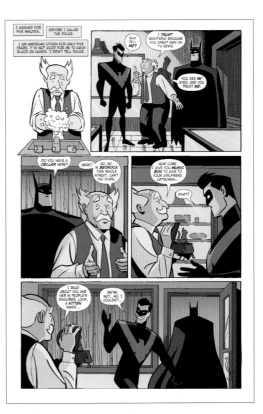

regularly by comic publishers, it's wise to know which one your colors will ultimately be printed on.

All comic book paper is made up of what's called groundwood pulp. Paper that appears slightly grayish, referred to as newsprint, is made up of pure, untreated groundwood pulp. Brighter and whiter paper stocks are manufactured by adding chemicals (especially bleach) to the pulp. Some paper is covered with a thin coating of varnish, which gives it a brighter appearance and prevents the ink from soaking into the paper too much. This results in purer, brighter color reproduction.

The technical term for how much ink is absorbed into a particular paper stock is press gain or dot gain. This phenomenon occurs in all paper stocks to different degree, depending on the paper's coating and weight, and the type of press it's being printed on.

Most comic book covers are printed on the best comic book paper available: coated, bright white stock that is usually much thicker than most interior paper. So, keep that in mind when coloring cover images.

RGB TO CMYK CONVERSION

Earlier in this book, I highly recommended that you work in CMYK mode rather than RGB mode. Here's another reason why. Because the RGB mode is intended mainly for viewing colors on a computer monitor (as opposed to being viewed on the printed page), RGB colors are often extremely vibrant, almost electric in appearance. After all, your monitor is made up of zillions of little lights shining directly at your face! When converted to CMYK and then printed as ink on paper, there's no way those same colors can possibly appear nearly as bright.

PERSONAL PRINTERS

Although many home printers are very high quality these days, they can't possibly compete with the quality and accuracy of a printing plant's professional printing press. Even if your monitor is calibrated, and you're printing on very white, coated paper, and you're working in CMYK, your home printer will most likely give you different results than what you saw on your monitor. You'll have to monkey around with your printer's settings in order to come close to what your work looks like on screen, but even then, it's relatively impossible to replicate that look exactly.

TEN
SHOWING YOUR WORK

Once you've practiced the craft of coloring long enough and you feel like you're ready to do professional work, you'll need to put together a portfolio. Unlike the expensive portfolios that pencillers and painters maintain, any colorist can whip up a professional-looking presentation without spending a lot of money. Just about all art supply stores sell inexpensive folders with built-in clear sleeves that hold 8 1/2″ x 11″ printouts. Itoya's Profolio is a great brand.

 You'll want to display about ten sample pages. These should be printed at around 300 dpi on a desktop inkjet printer, preferably on glossy paper. Show mostly interior pages, since that's probably what you will be working on when (and if) you get a paying gig. To show your range, you might want to include a few cover images too.

 Only show your best work. If you don't have ten great pieces to present, then you're not ready to show your work. Remember, there's no rush. Keep practicing your craft until you're absolutely convinced it's time to start pitching yourself as a pro.

 Many comic editors attend the big comic book conventions that are held around the country each year. Once you've put together your portfolio, track down an editor or two (or three) and ask if it's okay if you show them your work. If you present yourself and your work in a polite, professional manner, most editors will be happy to look at your samples. Every editor knows that if you can't be professional and relatively pleasant at this early stage in your career, you'll only become worse as time goes by. Editors already have enough headaches to deal with without adding to them.

 If an editor shows interest in your work, either leave a small packet of samples with him, or ask him if it's okay if you send some printouts to his office. The editor will be honest. If he doesn't like your work or isn't really looking for any new colorists at this time, he'll tell you. Take any advice they give, practice for another six months, and try again.

 Remember, be a pro, smile, say thanks, and go looking for another editor. All it takes it one editor to like your stuff. Keep trying until you find him or her.

Colorists can create a professional-looking presentation using inexpensive folders with clear sleeves, such as Itoya's Profolio brand.

PART

THREE

TRUE--STIL
POSSIBLE.

TRUE--STI
POSSIBL

L E T T E R I N G

WHAT I *MEAN*
TO SAY IS YOU'RE
OVELY AND PERFECT,
AND I *ADORE*
YOU.

WHAT I *MEAN*
TO SAY IS YOU'RE
LOVELY AND PERFECT,
AND I *ADORE*
YOU.

I WISH
THAT WERE
TRUE--ST
POSSIBL

When someone learns that I work in comics, their first question is often, Do you draw the pictures? When I explain that I do the lettering—the words in the balloons, for instance—the next question is often, So, you write the stories? I hope in this book to explain exactly what comics lettering is: putting the writer's words on the artist's pictures.

The letterer's job consists of creating everything on the comics page that's made of words: the balloons, captions, sound effects, display lettering, titles, signs, and sometimes the logos. It usually also includes inking the panel borders on pencilled comics art. We'll discuss all those areas of lettering, as well as techniques such as balloon placement, accuracy and readability, making the text fit, and adding creative and stylistic touches that enhance the finished product.

Is lettering for you? It is if you want to create the full package: writing, lettering, and drawing your own comics. It may also be a way to get work in comics. At DC Comics and other large companies, lettering stands alone as a separate step in the comics creation process, usually between the pencilling and inking stages for hand lettering, after inking for computer lettering. Why don't artists letter their own pages? Some do. Many artists, though, can't or don't want to letter. Certainly it takes a different set of skills than writing, drawing, or inking. If you'd like to develop those skills, either for your own comics art, or as a possible way to participate in creating comics, you've come to the right place. Learning more about lettering can also help you be a better comics writer, artist, colorist, editor, or comics production staff person. The more we all work together, the better the final result will be!

Lettering is certainly a craft that can be learned. Doing it well also requires talent. I'll do my best to convey the former, the latter is something that can't be taught. The two things you'll need most to learn lettering are patience, and lots of practice. Practice daily, using the examples in this book, and also study lettering on original comics art if you can acquire some. If you see improvement after a month, and are still enjoying the process, you'll be on your way.

The big debate:
Hand versus Computer Lettering

A Lettering Sampler, opposite, was done in 1993 partly as a reaction to the growing tide of computer lettering then entering the comics business. The next year I bought a computer and started working on my own fonts. Hey, a guy can change his mind, can't he?

Seriously, this has been the most hotly debated topic among working letterers over the past decade. Those on one side declare that computer lettering is cold and impersonal—too regimented and limiting to work well with hand-drawn art. Those on the other side reply that computer lettering is obviously the way of the future, as it has some distinct advantages to publishers who are geared for it, and provides the individual letterer with new work options that hand lettering alone doesn't offer.

I come down firmly in the middle on this question. I think both sides have valid points, and the best course for anyone who wants to pursue lettering from today forward is to learn as much as possible about both methods. Hand-letterers can bring their creative skills to the computer (which is only as creative as what you put into it), and computer letterers can benefit from learning to do things by hand. If you can master both you have the most options, and the best chance of being the right person for any lettering task.

One big factor for either method is startup cost, and there hand lettering is the clear winner. Tools and supplies for hand lettering are far less costly. Computer lettering does offer more chances of working in a studio or production staff setup, though, where you can learn on the job using someone else's equipment before deciding to make the investment in equipment of your own. I'll be covering both computer and hand lettering, but they're so different that I've put them in separate sections. Hand lettering comes first, and much of what we'll cover there will also apply in the computer lettering section. Hopefully, you'll refer to the other fine books in this series for information about writing, pencilling and inking comics, and to this book's coloring section for more info on that topic.

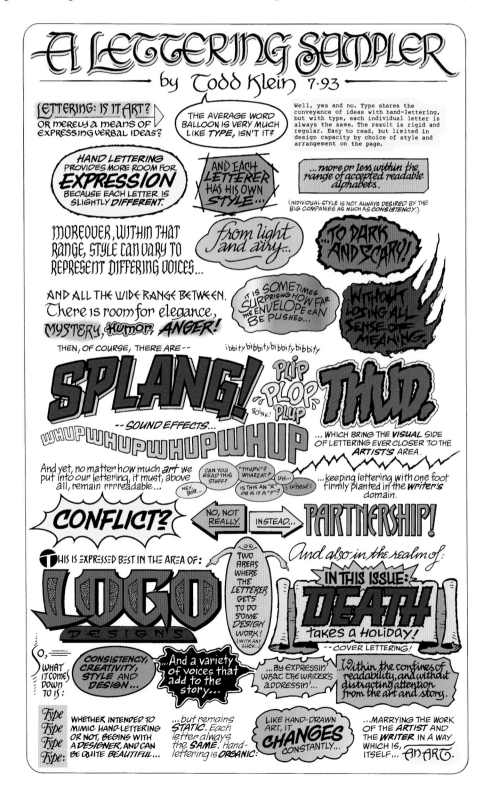

TWELVE
TOOLS AND MATERIALS

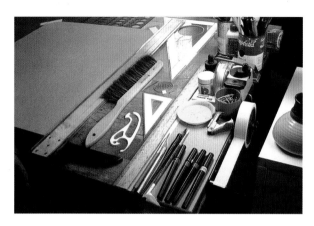

A well-stocked drawing board.

Lettering, like any art or craft, needs a work space. This can be as small as the corner of a room, but basic to the furnishings are a drawing table, a comfortable chair, adequate lighting that avoids shadows on your work space, and a side table or taboret for tools and materials. You'll also want a T-square with transparent plastic edges, an 18 inch 30/60 degree acrylic triangle with beveled edges, a small triangle for close work, an 18 inch ruler, a dusting brush, and a masking tape dispenser. Other items you may want are paper towels, a wide-based water mug, brush and pen containers, regular tape dispenser, stapler, scissors, and trash basket.

Now some specific tools and materials for the job. While any pencil will work, I prefer a lead holder and #2H leads. You'll need a lead pointer to sharpen it. These leads sharpen to a finer point than most pencils, and hold the point longer. For an eraser, Sanford Magic Rub. For corrections, white retouching paint such as Pro White and an inexpensive watercolor brush. For inking balloon shapes, circle and ellipse templates. I use the Pickett 4-in-1 Ellipse Template #1262i, and any circle template. You may want french curves and ship curves for inking long balloon tails or curved borders. You'll also need an Ames Lettering Guide (we'll cover its use in detail.) For inking large black areas, a high-quality ink brush such as a Winsor & Newton Series 12 Red Sable #3. For cutting, an X-acto cutting knife with #11 blades, and if you plan to do any paste-ups, Best Test One-Coat rubber cement and a rubber cement pickup. I'd also recommend a cutting mat and a small light box. The latter is a must if you do a lot of paste-ups, but you may want to wait until you need it. For doing lettering samples, you need a cotton fiber art paper such as Strathmore Bristol Board. Most comics art is done on 2-ply thickness, but you can use 1-ply for practice and correction patches. I prefer the high or smooth finish, but many comics pencillers use the medium or kid finish, and the paper choice is made by the penciller, so you should practice on both. For lettering over finished ink artwork, I use translucent vellum paper such as Canson Vidalon 90, which is also helpful for making layouts and samples.

I've saved the trickiest things for last: pens and ink. As computers have taken over the graphics field, the market for these tools has dwindled, which makes finding the tools you need difficult. Here are my recommendations, but I encourage you to try any tools you come across to see if they'll work for you.

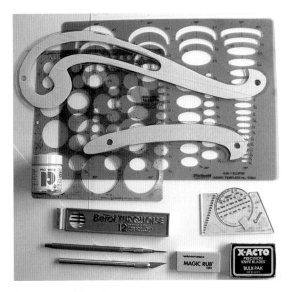

Lettering-specific tools.

There are two types of pens used for lettering: dip and technical pens. The former are the classic metal pen points inserted in a pen holder that have been used for calligraphy for centuries, based on the quill pens of ancient times. The latter are a type of refillable reservoir pen similar to a fountain pen, but ending in a thin tube that produces a consistent line of different sizes depending on the point used. I recommend you try both kinds.

For dip pens, Speedball/Hunt makes pen holders and points. Speedball points have an ink reservoir that holds a small amount of ink for longer use, and they come in four point styles: A (square), B (round), C (wedge) and D (ellipse). For regular lettering some prefer a B-6 (the smallest size) point that has been filed down on a sharpening stone to reduce the point size. This needs a lot of trial and error to get a point you like. Others prefer the C-6 point right out of the box, giving the classic thick-thin line. A third option is the Hunt #107 point, which has no reservoir and takes a smaller pen holder. This point is also filed a bit to create a wedge tip. Larger Speedball B and C pen points are used for display lettering.

For technical pens, the brand I've long preferred is Faber-Castell TG1. Unfortunately, they're no longer available in the US, though you may be able to find them online. The main US option is Koh-i-noor Rapidograph. They come in a variety of line sizes measured in millimeters and (points). For regular lettering I recommend 0.50mm (2), for bold lettering 0.70mm (2.5), for extra bold 1.00mm (3.5 or 4), and for small letters and touch-ups 0.35mm (0).

Ink for lettering must be waterproof when dry and as opaquely black as possible, while still able to flow through a pen point without clogging. It must also hold up to erasure, and should work well over white retouch paint. In the last decade many ink formulas have changed, making the task of finding the right ink much harder. My current favorite is Calli Jet Black India #010, but Speedball Super Black India also works well, and I try new waterproof inks when I find them. You'll need a small bottle with a dropper top, and if you find an ink you love, buy larger refill bottles.

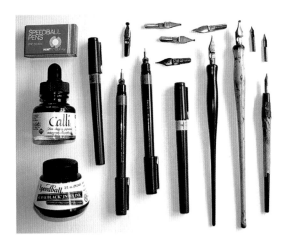

Pens and inks.

COMIC BOOK LETTERING (SHOWN HERE AT ACTUAL WORKING SIZE)

METRIC SCALE (DO NOT USE)

PENCIL POINT HERE

USE THIS SCALE

REFERENCE MARK

EDGE OF T-SQUARE

PLACE THIS MARK ON BOTTOM LINE TO BEGIN ANOTHER SET.

AMES LETTERING GUIDE

SLIDE LETTERING GUIDE HORIZONTALLY

SET UP YOUR *PAPER, T-SQUARE* AND *GUIDE* AS IN THE SMALL DRAWING. SET THE WHEEL AT 3½, AS SHOWN IN LARGE DRAWING, FOR STANDARD COMIC LETTERING. PLACE PENCIL POINT IN ONE OF HOLES MARKED, AND WHILE HOLDING T-SQUARE WITH ONE HAND, SLIDE *GUIDE* ACROSS PAPER WITH PENCIL POINT. REPEAT WITH EACH HOLE, AND YOU WILL HAVE THE GUIDE-LINES FOR *THREE ROWS* OF LETTERS.

Okay, you have your tools and you're ready to begin. Let's look closely at the Ames Lettering Guide, as pictured, and use it to draw some lettering guide lines. These are rows of pencilled lines marking the top and bottom of each row of letters.

Position your art paper squarely with your T-square, tape it at the upper corners, and position your Ames Guide as shown. The drawing shows the bottom row of grouped holes being used, which I prefer, but you can also try the top row of grouped holes, and the center row is also useful for wider row spacing. Set row height by rotating the circular section to the setting you want on the regular scale (not the metric scale). I usually set it for about 3 and 1/2 or a bit less. Marking the center point between numbers 3 and 4 with your X-acto knife will help you find the right spot. Larger and smaller sizes can be used as well, when the job requires it.

Now hold the T-square with one hand to anchor it, and placing the pencil point in the first hole, slide the Ames Guide with the pencil to create a horizontal guideline. Notice that the top and bottom holes in each group are all you need to use. When you've made three pairs of guidelines, move the T-square and Ames guide down, align the extra top hole in the row with the bottom line you've already

drawn, and draw three more pairs. This process can cover an entire practice page, or just the areas on pencilled comics art where you'll be lettering. When making guidelines over pencilled art, press just hard enough with your pencil to make the guides visible over the artist's pencil lines.

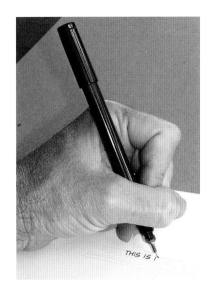

Now it's time to begin lettering with the pen of your choice. Put ink in your pen; if it's a technical pen, fill the cartridge and shake the pen gently up and down until the ink starts to flow. If it's a dip pen, either fill the reservoir with a few drops of ink from the dropper, or dip the pen just far enough into the bottle to fill the reservoir, wiping excess on a paper towel. Hold the pen in a way that is comfortable for you, but try to find a position that allows your wrist to remain as straight as possible, to avoid carpal tunnel problems. Your grip should be relaxed. White knuckles mean you're gripping too hard! As you work, keep trying to relax your grip, which will tend to tighten. Stop frequently to flex your fingers and shake the tension from your hand. Technical pens need to be held fairly close to perpendicular to function well, while dip pens are held at closer to a 45-degree angle. With dip pens, the direction and angle of a wedge-shaped point makes a lot of difference to the shape of the lines, so experiment with different angles to find one that works for you. Note that, while different technical pens are used for regular and bold letters, with dip pens you can use the same pen, but simply press harder to create heavier lines. This works particularly well with the Hunt #107 point. Or, use different points for thicker lines. I sometimes alternate between dip and tech pens for regular and bold lettering —a tricky juggling act—so experiment and see what works for you.

For your practice session, warm up first with the practice strokes shown. Your goal is to learn to create strokes that are consistent: evenly spaced, even in height and angle. Lots of regular practice will eventually pay off for you here. Now copy the comics alphabets shown. Try to keep your vertical strokes vertical. Horizontal strokes can drop slightly at the left side, especially when following the bottom guideline. This helps keep the letters visually separate. All the letters should be about the same width, except for M, W, and I. When making the small loops of B, P, and R, and the cross stroke of A, leave as much white space as possible in the center. Practice with rows of the same letters, then alternate with lettered sentences that use all or most of the alphabet, such as "the quick brown fox jumps over the lazy white dog." Copy dialogue from one of your favorite comics. Letter whatever appeals to

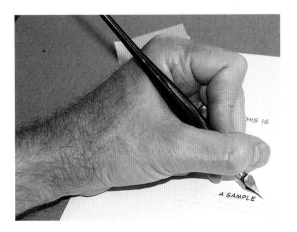

you, striving always to keep it consistent. Don't worry about style at this point. Save your practice pages, and compare them frequently. If you can practice at least an hour a day for several weeks, you should see some improvement. And if you're not completely sick of lettering by then, you may have the patience it takes to letter comics!

Above and left, holding tech and dip pens. Note that the author is left-landed, right-handed position will differ slightly.

IIII //// \\\\ ☰☰☰ OOO IIII //// \\\\ ☰☰☰☰ OOO IIII //// \\\\ ☰☰☰ OOO IIII //// \\\\ ☰☰☰ OOO IIII //// \\\\
ABCDEFGHIIJKLMNOPQRSTUVWXYZ?!"" ",.-,,,\'*#&;<()1234567890
IIII //// \\\\ ☰☰☰ OOO IIII //// \\\\ ☰☰☰ OOO IIII //// \\\\ ☰☰☰ OOO IIII //// \\\\ ☰☰☰ OOO IIII ////
ABCDEFGHIIJKLMNOPQRSTUVWXYZ?!",.-,,,*#&;<1234567890

IIII //// \\\\ ☰ ☰ ☰ OOO IIII //// \\\\ ☰☰☰ OOO IIII //// \\\\ ☰☰☰ OOO IIII //// \\\\ ☰☰☰ OOO IIII //// \\\\ ☰ ☰ ☰
ABCDEFGHIIJKLMNOPQRSTUVWXYZ?!" ",.-,,,*#&;<()1234567890
ABCDEFGHIIJKLMNOPQRSTUVWXYZ?!" ",.*#&;<1234567890
IIII //// \\\\ ☰ ☰ ☰ OOO IIII //// \\\\ ☰ ☰ ☰ OOO IIII //// \\\\ ☰ ☰ ☰ IIII //// \\\\ ☰ ☰ ☰ OOO IIII //// \\\\

Standard practice strokes and alphabets at working size, made with tech pens *(top)* and dip pens *(bottom)*.

Let's study the comics alphabets for a moment to see what's unique about them. First, why are they usually all capital letters? Tradition is part of it, but more than that, practicality. Capitals appear larger on the finished art, and can be spaced closer together, since there are no strokes extending below the baseline, as happens with the lowercase letters g, j, p, q, and y. Next, notice that unlike many typefaces, the letters are all sans serif, except the capital I and sometimes the J. This means there are no serifs or end-strokes on most of the letters. The capital I has them, and is only used for the personal pronoun I and contractions such as I've and I'll. In all other places, use the lowercase, sans-serif letter. This tradition helps make comics lettering easier to read. The serif on the J is optional, and there to help balance the shape of that letter. The last area to focus on is punctuation and special characters. Punctuation in comics has its own traditions, such as the use of the double dash and the ellipsis (three periods). Special characters like the radiating dashes are part of the comics vocabulary. I call them breath marks, as they are often used around words such as *sigh* and *whew* to indicate breath with no voice. Look through comics for unique punctuation and special characters. Use those you like, and create your own when the occasion arises.

When you're done with each day's session, wash and wipe off your tools, especially pens and brushes. Tech pens will work for some days with one filling of ink, but when they do become clogged, you'll need to very carefully take them apart, wash all parts, and wipe out with paper towels. Blowing water through the tube can help clear it. Be especially careful not to bend the wire that rests inside the tube. Dip pens will need to have dried ink scraped off with your X-acto periodically as it builds up under the reservoir or behind the point. Try not to bend the point or reservoir too far out of position when cleaning. Brushes will benefit from cleaning with liquid dish soap or a cake of brush soap occasionally. Always leave brushes to dry in a point. When an ink brush's point no longer holds, it's time for a new one.

Castell tech pen disassembled for cleaning. Handle wire insert, second from left at the top, carefully when reinserting in the inking tube. Don't force it. Hold the tube upright and jiggle until the wire slides down into place. If the wire becomes bent, you'll need to replace the point. Fill the ink reservoir, upper right, with the dropper on your ink bottle. Don't overfill, leave space for the point barrel to slip inside at the top. To get ink flowing, shake the pen up and down repeatedly and tap the base (not the point) on your drawing board.

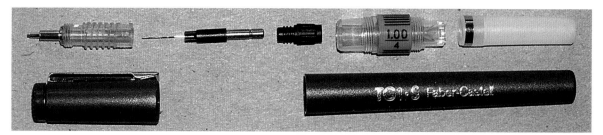

FOURTEEN
LETTERING TEXT AND
BALLOONS

After you've spent some time practicing strokes and letters, move on to creating the actual balloons and captions that make up the bulk of the letterer's task. Here are some things to consider.

Spacing between letters should also be consistent. Letters that are too close will run together when printed, becoming hard to read. Too much space is also a problem, breaking words up visually. Try keep about as much space between each letter as the width of your widest pen stroke. Leave a little extra space for punctuation and the lowercase I. Next consider spacing between words: it should be about the width of your average letter for good readability. Note that this space is a bit wider for bold words.

Leading is a printer's term for the vertical space between rows of type. It can also apply to lettering. Too little leading makes lettering hard to read, while too much uses excess space on the page. Leading will be affected not only by the guidelines you draw, but also by how much your strokes fall above and below those guides. If you're leading seems wrong, try using a different row of holes on the Ames Guide.

Most comics balloons are rounded or oval in shape. Practice breaking your work into different-length lines to fit into an oval: shorter lines at the top and bottom, longer lines in the middle. Hyphenating words can help, but use hyphenation sparingly, and if you're not sure where to break a word, check it in a dictionary for syllable breaks. Compound words like *northeast* are easy to break, but many words such as *thorough* don't read well when hyphenated (THOR- on one line and OUGH on another reads quite oddly). Never hyphenate one-syllable words. So, how else can you make it fit? The best alternative is to change the width of your lettering where necessary—condensing each letter slightly when you need to, and extending it slightly when you can. This takes some practice, and shouldn't be overdone, but can help make the letters fit into the balloons. Fortunately, captions are a lot easier, since they're generally rectangular! Center your balloon lines as best you can as you go along, but don't worry if they don't center perfectly. A general appearance of centered lines is what matters. For captions, begin each line at the left, and center only the final line.

Once you have some text in balloon shapes, it's time to draw the balloons. In the early days of comics this was always done freehand, using a series of scalloping curves around the lettering. Today, perhaps due to the influence of the computer, balloons are often more symmetrical, and created using ellipse and circle templates. You might want to try both methods.

Begin by drawing a loose, freehand oval around your lettering in pencil, leaving about a letter's width of space on all sides between letters and balloon border. Think about where your balloon tail will go, and indicate it. The direction of the tail should point to the speaker's mouth at one end, and to the center of the balloon at the other. Now consider what pen you'll use to ink the balloon border. If

The balloons at the top of the page read:

AFTER YOU HAVE *LETTERED* SOME WORDS AND *ARRANGED* THEM IN BALLOON-SIZE OVAL FORMAT...

...IT'S TIME TO *DRAW* AND *INK* THE *BORDERS!*

...IT'S TIME TO *DRAW* AND *INK* THE *BORDERS!*

...IT'S TIME TO *DRAW* AND *INK* THE *BORDERS!*

...IT'S TIME TO *DRAW* AND *INK* THE *BORDERS!*

Leave about one letter-space between lettering and border all around. Ink larger balloons in sections, using different ovals for the sides and top and bottom.

you're lettering with a dip pen, and feel confident in your curved strokes, go right ahead and ink along or close to your pencilled guideline in several smooth strokes. If you're using tech pens, choose your pen point (usually the bold size), and use ellipse and/or circle templates to follow your pencilled guidelines. Note that you will usually need to ink a balloon in several sections, using different ellipses for the top and bottom than you do for the sides, as shown. Short tails are usually best done freehand, but long ones can benefit from using a curve or triangle. For very large balloons you may need to break your oval shape up into even smaller sections, or use a french curve for the longer arcs. Try to join the sections cleanly, and fix any rough joins with white paint. Regular caption borders can be inked most easily with your T-square and triangle. Other styles may need to be done freehand.

While the oval and round balloons are the most difficult, many other shapes will be needed in most lettering jobs. Some examples are shown below, such as the burst, electric, thought, whisper, rough, telepathic, and wobbly balloon shapes. Most of these are traditional, though open to your creative interpretation, as long as you get across the style that the story requires. Look for more examples in comics you like, and create your own, but remember to use unfamiliar styles sparingly to avoid confusing the reader, and always refer to the story when deciding where to use them.

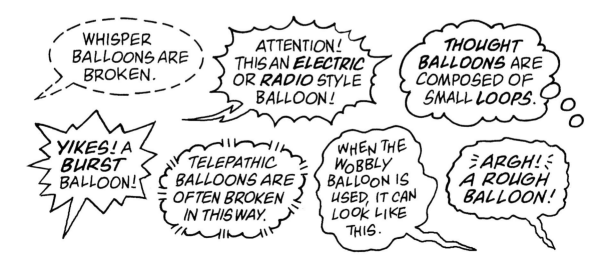

The term display lettering means any case where regular lettering isn't enough, where you need something extra to create excitement or gather focus. When a character dramatically SHOUTS a defiant statement, when the writer excitedly describes what will happen NEXT ISSUE, when a new villain is ANNOUNCED, when a crowd SCREAMS—these are some places for the extra emphasis of display lettering, as well as nearly anything lettered on a comic book cover.

ABCDEFGHIJKLMN ABCDEFGHIIJKLM
OPQRSTUVWXYZ!? NOPQRSTUVWXYZ!?

ABCDEFGHIJKLMN
OPQRSTUVWXYZ!

Samples of display lettering. At top, created with larger Speedball points, B-3 and B-5. The second row at top right has the rounded corners pointed with a #0 tech pen. At bottom are open letters created on a grid pattern, pencilled first, then outlined with a tech pen, T-square, and small triangle.

Smaller display lettering is often an enlarged version of regular bold lettering created with larger-point Speedball dip pens, as in the examples shown. To make it more forceful, you can square the corners of the larger letters with your smallest tech pen. The next step up is open lettering, where the letter shapes are outlined in black and filled with color. Sound effects most often use this technique.

One good place to begin the process is with a block letter grid, as shown. This grid uses pairs of equally spaced guidelines, much like those made with the Ames Lettering Guide, but on a larger scale. By varying the grid spacing, you can create many different block letter styles, from very thin to very thick. Different horizontal and vertical grid sizes on the same letters can produce other useful styles. Once you have your grid mapped out, you can create very square, blocky letters with your T-square and triangle, rounded letters with circle and oval templates or any combination that looks good to you. For a more informal look, create freehand letter-forms in pencil, using the grid as your guide. The most important thing to remember about any open lettering is this: the reader's eyes define the letter mainly by the central white space, NOT the outline. If the central space is formed well, the letters will look

good. If not, they will look ill-formed, no matter how carefully the outline is inked. Think of open letters as tracing around the white space, and keep it consistent. Then do whatever you like to the outline beyond that to add emphasis and impact. Below are some examples.

Roughening the outer edge is one good technique, and adding a drop shadow or a second outline can help make the letters stand out. Reverse outlines can add drama, and running letters together can provide a nice design element, as long as the letters remain readable. Varying outline weight, adding texture, and breaking panel borders all help add excitement. Use all effects sparingly, though, and don't try to overpower or cover too much of the art. Follow the suggestions of the penciller, when he provides them. It's also important to match the style of the display lettering to the effect called for in the story: bold, blocky letters for the thump of an impact, thin shaky letters for a ghostly wail, and so forth. Study the display lettering in your favorite comics, and look for the great variety of styles that can be used, and which ones best convey the intent of the story and complement the style of the artist.

Some display lettering effects, in order: shadow, drop shadow, open drop shadow, 3-D or telescoping, roughened outer edge, outline, reverse outline, fiery outline, drippy, notch and texture, icy or frozen, and roughly filled. Many others are possible, look for them in your favorite comics.

Opposite: some stellar examples of display lettering by Gaspar Saladino, from various DC covers, early 1980s. Gaspar's talent and creativity in this area have seldom been matched.

Signs, Titles, and Credits

All the elements on a comics page that are made of letters are also part of the letterer's job, unless told otherwise. This generally includes signs. I consider them part of the lettering unless the sign is three dimensional and so integrated into the artwork that inking it would impact the task of the inker. Pencillers who lay out signs in perspective, adding letter shapes and perspective lines will help you a great deal, but if that's not provided, you'll need to do it yourself. We'll talk more about perspective later, but in essence you want to follow the perspective of the sign surface, and lay out your guidelines in a grid format, then pencil in all the sign information provided, using the techniques discussed previously for display lettering. Follow the feel of the pencil art in deciding how precise to make the sign letters, and match the artist's style where you can.

Very small open letters can be difficult to do well, and hard to read in any case, so you may need to replace them with solid letters. When reproducing actual signs, such as road markers, look to the real thing for reference when you can. Reproducing corporate logos can be a legal problem, so substituting something similar is often a good idea.

Another important item is the story title, often a place for a letterer to both add to the story's impact, and display some creativity. First, look at the pencilled art of the page where the title and credits will go, and determine exactly how much space you can use without covering any important art elements or distracting from the intent of the picture. Titles most often go in the background over open areas of the page, but in some cases may need to run across picture elements. Follow the suggestions of the penciller when provided.

When you have the area in mind, lay a piece of vellum paper over the area to work out your title/credits design. This gives you a chance to try different approaches first, and make sure everything will fit before committing to ink on the artwork. Often you'll want to use a block letter grid as discussed in display lettering to lay out your title. Use your best design sense to make the title both express the meaning of the words, and the intent of the story. Think about which words are most important, and emphasize those. Consider using some of the effects discussed under display lettering as well, to add interest to the title. When happy with the layout, copy it onto the pencilled art and ink it.

Leave enough room for the credits. These can often go in a separate box, or in a banner running under or over the title, but there are other options such as incorporating them into open areas of the art, or into the title itself. Sometimes credits will go elsewhere in the

This title page from *Orion* #7 (December 2000) with lettering by John Workman features distinctive hand-lettered title, caption and credits design. Script and art by Walter Simonson.

comic, and don't need to be lettered. Credits usually follow this order: writer, penciller, inker, colorist, letterer, assistant editor, editor, creator (if any). If you're working for others, check with the editor to make sure you have all the necessary names, and correct spellings. Look for title and credit examples in your favorite comics to see which ones work the best.

Some Words on Personal Style

As you look at the lettering examples in this book and elsewhere, you'll notice that within the standard comics lettering format there are many individual styles used by different letterers. If you stick with lettering long enough, you, too, will develop a unique, recognizable style, but that's not something to strive for. Instead, keep practicing and developing the basics, use the standard alphabet models to the best of your ability, and in time your own style will emerge. As you learn, study the work of others you admire, and try to utilize their techniques—not exactly, but as a guide. Don't be afraid to be creative if the situation calls for it, but remember that simplicity is always best, and above all, strive to keep your work readable. Listen to any criticism you get, and attempt to be your own hardest critic. Compare your work closely over time. The ability to see and analyze your own shortcomings is the best way to improve on them, and the attention to small details is the difference between good work and great work. Personal style is what happens to you along the way.

Borders and Page Numbers

When you're lettering on pencilled art, it's part of the letterer's job to ink the panel borders, unless told otherwise. Follow the indications of the penciller carefully, especially if they indicate different line weights in some areas. I generally rule borders with a triangle and T-square where possible to keep them square to each other, and use a bold-weight tech pen, or in some cases extra-bold, especially where panels join without a white dividing area. Circular borders should be lettered with a compass that has a tech-pen-holder attachment, or in some cases you can use circle templates. Curved borders can benefit from the use of french and ship curves, while rough shapes are best done freehand.

Hand-lettered page numbers used to be common, but are now rare. If they're required, make sure you know where the editor or artist wants them—usually centered below the bottom panel on non-bleed art, or in a circle or rectangle on bleed art. If page numbers aren't wanted, you should still put the story page number somewhere on the page, outside the art area, for reference.

A creative variety of panel border and page number styles, designed by Mark Buckingham, in *Fables* #14 and #15 (August and September 2003). Script: Bill Willingham. Pencils: Mark Buckingham. Inks: Steve Leiaoha.

Once you've learned the basics and are comfortable with them, you may want to develop some of these additional skills to add to your lettering portfolio.

Comics scripts sometimes call for other alphabets than the ones we've used so far. A mixed-case (upper and lowercase) alphabet can be useful for variety, or special caption style. As said before, lowercase letters look smaller on the page, and require extra space between lines, so the best approach is to keep the lowercase height (called the x-height) as high as possible in relation to the capitals, and also to keep the descent strokes (lines going below the baseline on letters g, j, p, q, and y) as short as possible. A handwriting or script alphabet is useful for captions that are meant to be from a journal or diary. Since it's mixed-case, the same techniques apply. Some stories will call for robotic or alien alphabets that you'll need to create. Remember to keep it readable! To represent ancient times, or a fantasy setting, a calligraphic alphabet is helpful. A wedge-point dip pen is ideal for this, and calligraphy textbooks can supply some useful techniques and alphabets. Sometimes you'll want a typewriter alphabet to indicate a typed note or caption. Adding serifs takes a good deal of extra time, but done carefully, this can be an appealing alternative to putting in actual type. Some examples are shown here, but you'll find lots more if you look for them. As always, don't overdo this kind of thing!

MIXED CASE: abcdefghijklmnopqrstuvwxyz abcdefghijklmn opqrstuvwxyz The quick brown fox jumps over the lazy white dog. AaBbCcDdEeFfGgHhIiJjKkLlMmNnOoPpQqRrSsTtUuVvWwXxYyZz

HANDWRITING: abcdefghijklmnoprstuvwxyz The quick brown fox jumps over the lazy white dog. aAbBcCdeEffFgGGhHi IjJkKlLmMnNoOpPqQrrRssSStTTuUvVwWxXyYZ

ROBOT: ABCDEFGHIJKLMNOPQRSTUVWXYZ THE QUICK SILVER ROBOT
ALIEN: ABCDEFGHIJKLMNOPQRSTUVWXYZ JUMPED OVER THE
CALLIGRAPHIC: aBCDEFGHIIJKLMNOPQRSTUVWXYZ THE LAZY WHITE ELF
TYPEWRITER: ABCDEFGHIJKLMNOPQRSTUVWXYZ abcdefghijklmnop

Some writers will ask for you to develop a unique lettering style for a particular character or story. This can be an effective way to make that character stand out, but the style needs to match the personality of the character, and not be so visually unusual as to distract from the story, or make it hard to read. Character styles can be as subtle as a slightly thicker border or one letter in an alternate shape from your usual alphabet. Or they can be as elaborate as having a melodramatically theatrical charac-

Opposite: Unique character styles from a variety of DC comics. *Top row:* From *Swamp Thing* #1 (November 1972) lettered by Gaspar Saladino; from *Watchmen* #4 (December 1986) by Dave Gibbons. *Center row:* From *Batman: Manbat* #3 (December 1995) by Ellie deVille; from *JLA: A League of One* (2000) by Bill Oakley. *Bottom row:* From *Books of Magic* #14 (July 1995) by Richard Starkings; from *Sandman* #69 (July 1995) by Todd Klein.

ter speak in the flowery, decorative style of a circus poster. Some examples are shown, and you'll find more in your favorite comics, but remember not to overdo. A story where every character uses a different style can be a nightmare to read.

When developing special styles and alphabets, non-traditional tools can help you get interesting results. Try lettering with a small ink brush, fountain pen, or different dip pen points than you're used to. Other tools such as a grease pencil or permanent markers can occasionally create good results, but need to be handled carefully, as they may smear, blur, or not hold up to erasure. White scratches with an X-acto knife or white retouch paint can also be used on heavy black areas to create texture. Even a very small sponge or your ink bottle dropper can be useful for effects. Experiment first, to make sure you don't create a disaster for yourself, or the inker.

You've done your practicing, prepared samples, and landed a lettering assignment. A package of art and script arrives from the artist or editor, with the usual note that they'll need it done as soon as possible. Now it's time to get started, but are you sure you're ready? Don't panic! Here are some tips to help you get going.

First, make sure you have everything you need from the sender. Scripts come in two basic formats: full script and dialogue only, depending on the style of the writer and the company. A full script will have a complete description of every page and panel, along with the dialogue for lettering, while a dialogue-only script will, of course, have only what you'll need to letter. If the sender hasn't included balloon placement guides to show you where to put each item, check with them to make sure they want you to do that yourself, and then refer to the Balloon Placement section below. Read through the script to see if there is any reference you'll need from previous work, and make sure you have it. Keep a good dictionary handy to check the spelling of any words you aren't familiar with, and if grammar or sentence structure seems wrong, call the writer or editor and go over it with them.

Now look at the pencilled art, if that's what you've been sent. Comic art for large companies is generally done on preprinted art paper with the art areas indicated in blue, as in the sample shown. Note that art can be full-bleed (going right to the edge of the printed page) or non-bleed. Crop (or trim) marks indicate where the printed page will end, but panels should always extend to the bleed border, or stop well inside the crop line. If the artist has art ending at the crop line, it will present a problem for the printer, and you should consult with the sender on how to handle it. The inner broken-line box on preprinted art boards defines the safe area for lettering. All your balloons and captions should stay inside that safe area. Sound effects can continue out to the bleed line in some cases. If you aren't working on pre-printed boards, make sure you find out where the safe area for lettering is. At original art size, 5/8-inch in from the crop or 7/8-inch from the bleed is usually standard. At printed size the safe area is about 3/8-inch in from the crop or 5/8-inch from the bleed.

Art and script samples: at the top is a page of full-bleed artwork from *The Demon* #16 (October 1991) by Val Semeiks, which runs to the solid outer blue bleed line printed on the paper. Below that is a page of non-bleed artwork from *Sandman* #49 (May 1993) by Jill Thompson. Look closely at the upper left corner and note the crop marks, which will form the actual edge of the comic page. Inside the panels is a broken blue line that indicates the safe area for lettering on all pre-printed art boards like these. The script page at the top, from *Superman: Secret Identity* #3 by Kurt Busiek, is in dialogue only format, having only the text that needs to be lettered. Below that is a page of script from *Fables* #19 by Bill Willingham in full script format, with both art descriptions and dialogue for each panel.

Balloon Placement

One aspect of lettering that seems to intimidate some people is deciding where to place the balloons on a page. When lettering for a big company, placements are often prepared by the editor or artist, but in other cases you'll have to do it yourself. First of all, remember, this is not rocket science! If you use what you already know about reading and some common sense, you'll do fine. Second, it's a lot harder than you might think to make a page truly confusing to read, but it's wise to follow the guidelines below to avoid slowing the reader down or making them give up in disgust.

In English, at least, we read across from left to right, skip down, then left to right again. This happens inside a balloon, inside a panel, and across a whole page. Most readers will scan an entire page first to enjoy the art, read any large display lettering or sound effects that jump out at them, then proceed to read each balloon. Keep this in mind when planning your placements.

Saga of the Swamp Thing #21 (February 1984). John Costanza's lettering placement on this unusual page layout encourages reading the captions and balloons in the correct order by judiciously overlapping the panel borders.

When you receive work to be lettered, go through the script and make sure the balloons are marked clearly and numbered consecutively, so you won't miss any. If the script is not clear, go over the items to be lettered with a highlighter marker, and/or number them yourself with a black marker along the left edge. If you can, make copies of the pencilled art, and do your placement planning there first, before starting to letter. Another method is to plan out tricky placements on vellum over the pencils. Draw in balloon, caption, and sound effect placements with pencil or marker, basing the size on how much text is to be lettered (this gets easier with practice). Number the placements to correspond to the item numbers on the script. When you're working with full-bleed art, make sure to keep the lettering in the safe area.

Ideally, balloons and captions shouldn't cover figures or art important to understanding the picture, but sometimes they must. Try not to cover hands and feet, and never cover faces of those speaking (though trimming off some of the hair can be okay, if necessary). Generally balloons look best above and away from the speaker. Jamming balloons in a narrow space between figures is not a good idea, especially between two faces. Be careful with overlapping of figures and art: keep it consistent. Balloons shouldn't go behind one part and in front of another part of the same person, for instance. Nor should they go in front of a foreground figure and behind a background figure.

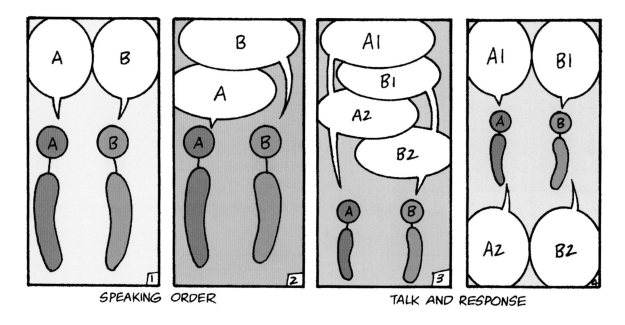

SPEAKING ORDER TALK AND RESPONSE

When having a hard time fitting the balloons into a panel, consider if you might either move something to the panel before or after, or overlap a panel border without confusing the reader. If that fails, you may need to ask the writer or editor to edit out some of the text. Within a panel, it's always best if the character on the left speaks first. Otherwise you force the lettering to take up more space, as in the examples shown. Talk and response in the same panel also requires extra space. Making the examples shown into two panels instead of one would work better, but of course, you need to deal with what you've been given.

Opposite are some page layouts that are least likely to create reading problems: horizontal rows of panels (grid format), a single vertical row, and a single horizontal row. With these last two, it's still wise to place the balloons to move from upper left to lower right when you can. When vertical and horizon-

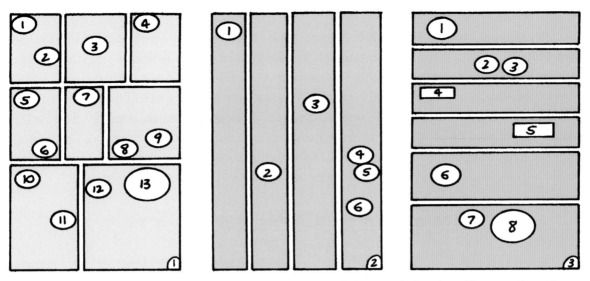

Balloon placement on easily read page layouts: panels stacked in rows, one vertical row, one horizontal row. These examples are for non-bleed art, where the safe area is the outer panel borders.

tal rows are mixed, or when angles are added, care must be taken to keep the reader on the right path, especially when the direction you intend goes against common reading practice. The best way to do this is to lead the reader across the page with a definite trail of balloons, as shown in the examples. Keep balloons that should read down rather than across close together or overlapped. Overlap panel borders to force an unusual reading order. Also shown are the same layouts with purposely confusing placements, to give you an idea what not to do. Even these aren't impossible to read, just more difficult!

Balloon placement on more challenging page layouts, showing poor placement above, better placement below, with red lines indicating intended eye movement across each page. Notice where overlapping the panel borders helps the reading order.

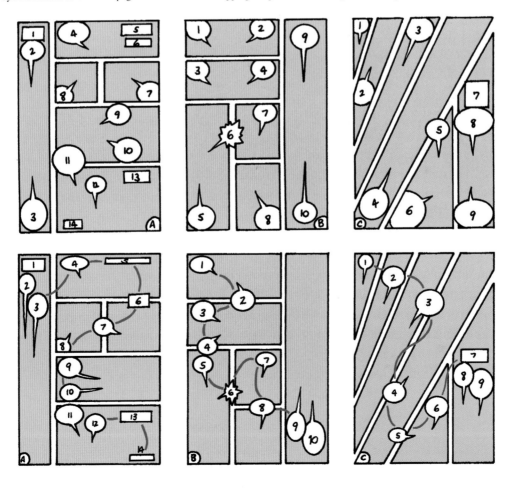

When faced with a challenge, ask yourself, "Does it really matter which of these is read first?" Sometimes it doesn't. When all else fails, go to the editor or artist for help — they may suggest changes in the art or script that will solve the problem. But keep in mind that the best person to solve placement problems is you, the letterer, especially as you gain experience. You'll often see solutions as you study the page that others have missed. If you see a better way to place a balloon than the indications you've been given, go for it. It's not rocket science, but careful placements can help tell the story and make everyone involved look good. When you have your placements worked out, go ahead and draw guidelines in those areas of the page with your Ames Guide and begin lettering.

Making Corrections

Nobody's perfect. Even when trying your best to be careful, you're going to make errors, and will need to fix them. For fixing wrong strokes or a few letters, use white retouching paint to cover them. When completely dry, you can usually letter over the paint, but use your smallest pen point for best results, as the ink tends to spread. For that reason, white paint isn't usually the best option for larger corrections such as long words or entire sentences. There you'll need to make a patch by lettering on a separate piece of one-ply art paper. It's often better to reletter a whole balloon than trying to patch in a single word or line. Paste your patch in place

Correction and paste-up tools.

with rubber cement after carefully cutting it to the right shape with X-acto knife or scissors. Another correction technique is to use an electric eraser, but you should use only fine-grain erasers, and erase sparingly to avoid roughing up the paper surface too much to reletter on.

Vellum and Paste-ups

Sometimes comic book art is inked before the lettering is done (because the penciller and inker are the same person, or working closely together, or to save time by having the inker and letterer working simultaneously). In that case you'll be sent either finished art or photocopies of the pencilled pages, and will need to letter them on vellum paper overlays. Trim your vellum to the size of the pages, and tape each one in position at the top edge, then do your guidelines with the Ames Guide and letter as usual. The only difference is that your ink lines will tend to be thicker than on art paper, even with the best vellum, so you have to be more careful not to run the letters together. One advantage of vellum is that nothing is final—mistakes can be fixed by either starting over, or cutting in a new section. When you're finished, erase the pencilled guidelines and be sure to mark the title and page on each overlay. Consider how the lettering will be lined up with the artwork: this is called registration. If positioning

isn't obvious, make some position markers or registration marks along the edge of one or more panels so it can be matched to the art later. The vellum will be photostatted or copied onto regular paper, then pasted onto the art.

In some cases you may be asked to do the lettering paste-ups yourself. This takes time, and usually requires an extra fee. You'll need a good copier to get the vellum lettering onto regular paper, and may need to experiment with different settings for the best copies. Once that's done, use a light box to put the copies into position over the art. Tape the lettering copy on one edge, then flip it back and put One-Coat rubber cement on the backs of all the lettering. When it dries, flip the paper back onto the art and press it firmly in place. Then use your X-acto knife to carefully cut around the outside of the lettering. When finished, remove all the excess paper, and use your smallest tech pen to fill in any white areas still showing between the art and the lettering, following the style of the art as best you can.

Samples of lettering on vellum overlays for *Terra Obscura* #6 (February 2004), in this case lettered over copies of pencilled artwork. Note the corner marks at the top of the first panel to help register the lettering with the finished art later.

Logos for characters and comic books are often handled separately from regular lettering, both in approach and as an item paid for. A logo is something that, ideally, will be used again and again if the character or comic is successful, and an outstanding logo can help a great deal in marketing and selling the project. Often logo design is handled by logo specialists, but if you're creating your own character or comic, and even if you're not, at some point you'll probably need to create one. Here are some suggestions on how to go about it.

The elements of a good logo are:

- Readability: it should be easy to read even from a distance.
- Strength: most comics logos benefit from bold, energetic, dynamic lines and shapes.
- Appropriateness: you need to match the style to your subject, perhaps even incorporate design elements from the character(s) or their world.
- Originality: obviously the hardest part is coming up with something new. No one said this would be easy!

Look carefully at your favorite comics and think about what makes their logos work (or not), based on these four principles, but don't forget to look beyond comics for ideas. Some places to look are type catalogs, book and magazine covers, advertising and packaging of all kinds, movies, and TV. Think about which logos are most appropriate to their subject, and how the designer achieved that. Take a familiar product, icon, or character and try creating new logo designs for it to help develop your skills.

Development of a Green Arrow logo: at upper left, small rough pencil sketches, then a more developed pencil sketch. Right of that and below, three tight sketches inked with markers and submitted. The sketch at bottom right, made after suggested changes, was approved.

When approaching a logo design, begin with lots of small, rough sketches, then pull out a few to develop further. Use a block letter grid to help lay out your letter forms. Start with a basic concept in a simple form, and then develop it further by adding effects, and using curves and perspective. Three types of perspective, as shown, can be used to give your letters dimension. Remember to only use them where they will be appropriate. When you have some tighter sketches developed in pencil, you can use markers to ink them quickly (this is one of the few places to use markers!) to see if you're on the right track. If working for someone else,

this is a good time to show these sketches for comments. You may find none will fit the bill, and need to do more sketches. If one sketch is preferred, develop that idea further, or in variations.

When everyone, including yourself, is happy with the final sketch, you need to render it tightly in ink. For this, use a plastic vellum such as Denril, which holds very clean lines but must be handled carefully, as it will pick up oil from your fingers that repels the ink. Tape the sketch to your board, and tape the vellum over it, then use your tools to produce the cleanest version you can. To ink a number of angled lines that are exactly parallel, you might want to get an adjustable triangle. For making large, accurate arcs you'll need a bow compass with a tech pen adapter. If you make a mistake, or to create sharp corners, carefully scrape away the dried ink with your X-acto knife. When you're done, mount your vellum on white illustration board and add a cover of art paper. Don't forget to make good copies at diferent sizes for your own files, and to paste onto any stories you'll be lettering.

Additional tools for precise logo design: adjustable triangle, and bow compass with tech pen holder attachment, also for drawing circular panel borders. Shown is finished logo for *Amethyst* drawn on plastic vellum and taped to illustration board.

PART FOUR

COMPUTER LETTERING

Now that we've covered the traditional, we'll move ahead to the electronic. Remember that you'll need expensive equipment and software to produce computer lettering, as well as lots of time to learn new skills, so be sure you really want and need to work this way. I'll be concentrating on techniques and software that I use daily. There are other programs and working methods available, and no doubt shortcuts I haven't discovered yet, which I encourage you to investigate. Note also that software is always being revised. While some specific tasks may differ slightly from the instructions here, your software manuals can fill you in on the correct methods for your version.

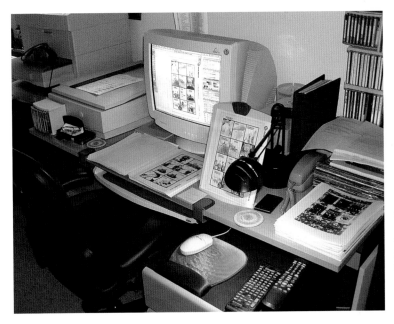

Computer work area.

Opposite: From *Batman* #618 (October 2003), part of a well-designed computer-lettered title page by Richard Starkings.

The first question you have to consider is which operating system to use. Much of the world uses the PC (Windows) system, but printing, publishing, and graphics companies generally prefer the Macintosh system, and we'll be using that for all examples. Much of what we'll cover can be done on a PC, but if you deal with others in the comics industry you may find it easier to use a Mac.

Consider your hardware budget carefully and divide it between these items:
- A desktop computer with the greatest speed and most memory you can afford.
- A 19-inch or larger monitor that produces sharp, clear images, especially of type.
- A laser printer that prints at least 600 dpi (dots per inch). 1200 dpi is better.
- A flat-bed scanner that scans at least 600 dpi, the larger the scan area the better.
- A CD-R drive, Zip drive, or second hard drive for backup, often built-in to your computer.
- A large desk or table to hold it all, and a place to work away from sun glare.
- A comfortable, ergonomic chair that you can sit in for hours (I recommend the Aeron Chair by Herman Miller) and good lighting.

Here's the software you'll need to get started, and others you might want to consider:
- Adobe Illustrator or other drawing program.
- Adobe Photoshop or other painting/scanning software (may come with scanner).
- FontLab and ScanFont (or Fontographer) for font creation.
- Commercial fonts as needed (some will come with the above programs).
- Extensis Suitcase or similar program to handle fonts.
- Programs to control and maintain your system such as anti-virus, disk maintenance, and fire-wall software.

Take time to read the manuals and work through the basic tutorials on all these items until you're familiar and comfortable with them. Don't try to do it all at once! Set aside a portion of every day to learn and use your new equipment. When you're ready, read on!

These balloons created in vector- and pixel-art programs look the same until you enlarge them. Vector art holds its precise outlines at any size.

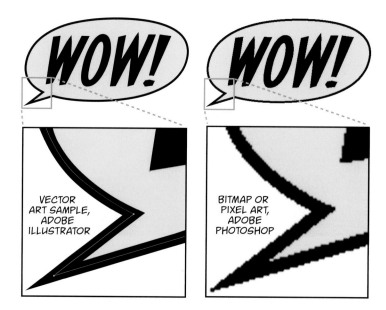

VECTOR ART SAMPLE, ADOBE ILLUSTRATOR

BITMAP OR PIXEL ART, ADOBE PHOTOSHOP

Computer programs that create art are divided into two very different types: painting or pixel-based programs, and drawing or vector-based programs. The coloring section of this book will focus on painting software—for lettering we'll deal mainly with drawing programs. I'll be using Adobe Illustrator for all examples, but Macromedia Freehand and CorelDraw are similar alternatives.

While painting programs, such as Adobe Photoshop, describe the color of each individual bit (pixel) of light in a file or document, drawing programs instead describe the outlines of all shapes with a mathematical borderline or vector path. This path can be enlarged or reduced, and changed in many ways without affecting its precise outline, and while vectors are represented as pixels on your computer screen, no actual pixels will be changed in a document until the outline is converted to pixels for use in a painting program or for printing. Vector paths can be open-ended, or have the ends connected to form closed shapes. Paths themselves don't print, but a path forms an outlined object that can have a fill and/or a stroke. The fill color of an object stops at the vector path. The stroke color follows both sides of the vector path, with the path at the center. Vector paths are defined and controlled by anchor points (or nodes), which appear on the screen as small boxes when an object is active or chosen. Anchor points can be chosen and moved individually, or in groups. When you choose an individual anchor point on a curved line, you will see one or two curve handles (also known as Bezier Control Points or BCPs) extending from the point. These handles can each be moved, controlling the curve of the line as it approaches the point.

Drawing programs offer a number of tools to help you create and manipulate vector paths and objects in each drawing or file you create. Basic shapes such as rectangles, ellipses, and stars can be created using the shape tools. Freeform lines and shapes are created using the pencil tool, and mathematically precise shapes are created using the pen tools. Type can be entered using the type tool (more on this below). Other tools help you work with and manipulate objects. Once you've created an object, all changes are made by adjusting the anchors and curve handles with the selection tools of the drawing program. To create open spaces within objects, such as the center hole in the doughnut shape of the letter O, a smaller object is drawn within a larger object, and the two closed paths are joined as compound paths, making the smaller one punch an opening through the larger one.

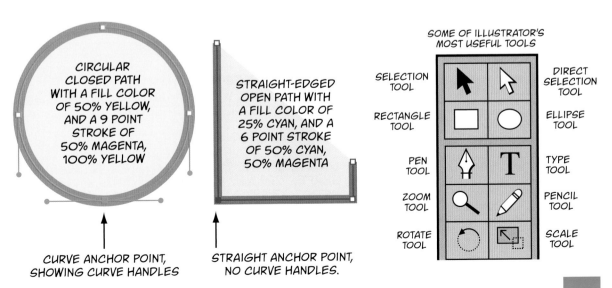

CIRCULAR CLOSED PATH WITH A FILL COLOR OF 50% YELLOW, AND A 9 POINT STROKE OF 50% MAGENTA, 100% YELLOW

STRAIGHT-EDGED OPEN PATH WITH A FILL COLOR OF 25% CYAN, AND A 6 POINT STROKE OF 50% CYAN, 50% MAGENTA

SOME OF ILLUSTRATOR'S MOST USEFUL TOOLS

SELECTION TOOL

DIRECT SELECTION TOOL

RECTANGLE TOOL

ELLIPSE TOOL

PEN TOOL

TYPE TOOL

ZOOM TOOL

PENCIL TOOL

ROTATE TOOL

SCALE TOOL

CURVE ANCHOR POINT, SHOWING CURVE HANDLES

STRAIGHT ANCHOR POINT, NO CURVE HANDLES.

Type is handled differently than all other objects in a drawing program. Instead of creating a line or shape, the Type tool enters alphabetical characters, numbers, and punctuation from the fonts available to your computer system. If you've ever used a writing program, or typed anything at all on a computer, you have used one of these fonts. All programs that use fonts include a list of available fonts or a font menu. In Illustrator, this list is found in the Character palette.

Letters entered on a document with the Type tool retain special properties that allow you to edit the type: change the font, type style, size, and other elements available in the Character palette. To access the actual outlines of the characters, you can change the type to outlines using the Create Outlines command in the Type menu. Once this is done, each letter will work the same as any drawn object, with individual anchor points that can be moved or changed. After conversion, though, you can no longer edit the type with the Type tool.

For comic book lettering in a drawing program, using fonts and entering text with the type tool is obviously going to be much faster and more efficient than actually drawing each letter one by one. So, how to you get hand lettering to work with the Type tool? You need comic book fonts.

The Character palette has many important uses for lettering. Clicking on the small box to the right of the font name opens a list of all fonts currently active on your computer. Drag up or down to the one you want. If a font has more than one style, a sublist will open at right. Drag to the one you want and release.

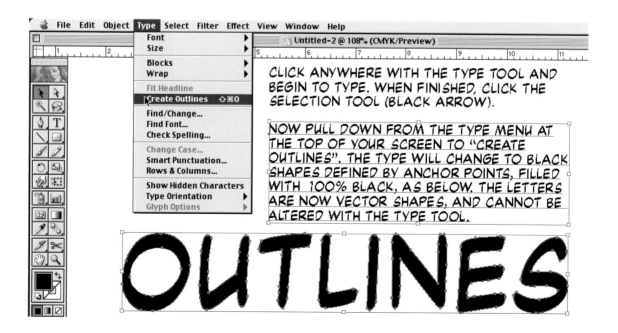

There are two ways to do this. The easier way is to buy commercial comic book fonts, available from several suppliers. Commercial fonts come in a number of appropriate styles that will allow you to jump right into computer lettering, but they do have some drawbacks. First, they're an extra expense, and each time you want a different style you have to buy another font. Second, you are limited to the fonts and styles available. Third, your lettering will look very much like that of others using those same fonts. If you want to produce computer lettering expressing your own individual style, you'll need to create fonts yourself. This is not an easy task, in fact it's downright tedious at times, but the results can be rewarding. If you're just getting started with computer lettering and want to try it out quickly, a commercial font or two is a good way to get a feel for the process.

E l e m e n t s o f a F o n t

The illustration below shows all the characters in a traditional typeset font, in this case Times Roman, showing where each character appears on the computer keyboard. Notice that different characters appear at the same keys when you hold down the Caps key, when you hold down the Option key, and when you hold down Both. Below is a similar breakdown of one of my computer fonts, Todd Klone–Wedge. Note that both the upper and lowercase slots are filled with capital letters. Look closely and you'll see that the capital pairs are slightly different from each other. The letter I is a special

Font Diagram for Times Roman

KEY	LC	SHIFT	OPTION	OPT/SHFT	KEY	LC	SHIFT	OPTION	OPT/SHFT	KEY	LC	SHIFT	OPTION	OPT/SHFT	
A	a	A	å	Å	Q	q	Q	œ	Œ	6	6	^	§	fl	
B	b	B	∫	ı	R	r	R	®	‰	7	7	&	¶	‡	
C	c	C	ç	Ç	S	s	S	ß	Í	8	8	*	•	°	
D	d	D	∂	Î	T	t	T	†	ˇ	9	9	(ª	·	
E	e	E		´	U	u	U		¨	0	0)	º	,	
F	f	F	ƒ	Ï	V	v	V	√	◊	-	-	_	–	—	
G	g	G	©	˝	W	w	W	Σ	„	=	=	+	≠	±	
H	h	H	·	Ó	X	x	X	≈	˛	[[{	"	"	
I	i	I		ˆ	Y	y	Y	Á	Á]]	}	'	'	
J	j	J	Δ	Ô	Z	z	Z	Ω	˙	\	\			«	»
K	k	K	°		`	`	~		˚	;	;	:	…	Ú	
L	l	L	¬	Ò	1	1	1	¡	/	'	'	"	æ	Æ	
M	m	M	µ	Â	2	2	2	™	€	,	,	<	≤	¯	
N	n	N		˜	3	3	3	£	‹	.	.	>	≥	˘	
O	o	O	ø	Ø	4	4	4	¢	›	/	/	?	÷	¿	
P	p	P	π	∏	5	5	5	∞	fi						

FONT DIAGRAM FOR TODDKLONE - WEDGE

KEY	LC	SHIFT	OPTION	OPT/SHFT	KEY	LC	SHIFT	OPTION	OPT/SHFT	KEY	LC	SHIFT	OPTION	OPT/SHFT
A	A	A			Q	Q	Q			6	6	£		
B	B	B			R	R	R	®		7	7	¢	•	
C	C	C	c		S	S	S			8	8	*		
D	D	D		-	T	T	T			9	9	(
E	E	E			U	U	U			0	0)		
F	F	F			V	V	V			-	-			
G	G	G	©		W	W	W			=	=	+		
H	H	H			X	X	X			[;	"		
I	I	I			Y	Y	Y]	;	"		
J	J	J			Z	Z	Z			\	\			
K	K	K			`	~				;	;	:	…	
L	L	L			1	1	!			'	;	'		
M	M	M			2	2	@	™		,	,	<		
N	N	N			3	3	#			.	.	>		
O	O	O			4	4	$			/	/	?		
P	P	P			5	5	%							

Most keys on your keyboard have four possible character slots, as shown, except in five cases, marked by gray boxes, where slots are reserved for combining letters with diacritical marks, such as é, î, ñ, and ü.

113

case: use the capital I only for the personal pronoun I and contractions such as I'm and I'll. Use the lowercase I in all other places. This is a convention of comics lettering that makes it easier to read. You'll also see that some characters are in different places, many are missing, and a few new ones are added. When you create your own fonts you have the option of following the traditional layout, or changing it to follow your own preferences, as I've done. Staying close to the traditional layout is a good idea, though, to cut down on confusion when typing.

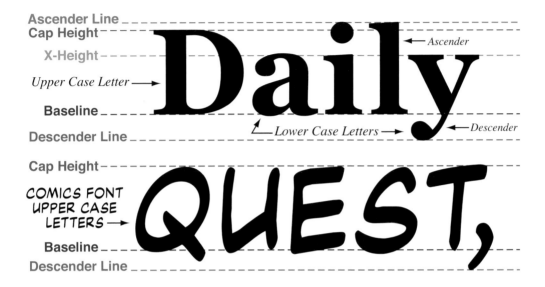

Above are the parts and descriptions of individual characters and their layout. Most important are the cap height, the baseline, and the descender. X-height is very important in lowercase letters, and the higher the X-height line, the larger the letters appear, but as most comics fonts consist of only capital letters, it won't apply to them. Likewise, the ascender and descender lines apply to lowercase letters. In a typical comics font, the ascender and cap height are the same. The descender is mainly used for the few characters that extend below the baseline, like the comma and the Q.

Fonts often have different styles, especially if they are used for text, such as italic, bold, and bold italic. A collection of these styles is a font family. Each style is a separate font that must be created individually. Comic book fonts used for text (balloons and captions) will need at least two styles: regular or roman and bold italic.

Times Font Family:

Times Roman

Times Italic

Times Bold

Times Bold Italic

TODDKLONE FONT FAMILY:

TODDKLONE ROMAN
TODDKLONE ITALIC
TODDKLONE BOLD ITALIC
TODD KLONE HEAVY ITALIC
TODDKLONE WEDGE
TODDKLONE SLANTWEDGE

Before you create a font, you need to hand-letter some characters. Letter them the same size and with the same method you'd use to letter on comics art. With the Ames guide, lay out pencil guidelines on a letter-size piece of art paper, then letter examples of all the characters you'll need in your font, but skipping every other line to leave more space. You should also leave extra space between each character horizontally, so that each character is surrounded by some white area. Warm up by doing many examples, using more than one piece of paper if you like. Don't forget numbers and punctuation and special characters!

For punctuation that doesn't fill the guideline from top to bottom, such as quotes, comma, period, colon, asterisk, and dash, use your smallest technical pen to draw short horizontal lines above or below (or both) to mark the boundary of the guidelines. This will help you size and position the punctuation later. Try not to approach this task with special precision—it should retain the looseness and informality of hand lettering. When you're happy with the examples, it's time to erase all pencil lines and scan.

Make sure your samples are aligned squarely on the scanning bed. Using the scanning software to prescan will help you check this. Select the area containing your favorite sample characters (three to five is plenty). Set the scanning mode for 1-bit line art and 600dpi. Set the software to scan at 300 percent of original size, and adjust the brightness or contrast to produce the most accurate reproduction of your original. You may have to scan and readjust this setting several times to get the best scan. Examples are shown below. Save your final best scan or scans as TIFF files.

A portion of the same letters scanned at different contrast settings: too dark, too light, and just right.

115

Creating a Font: FontLab or Fontographer?

For many years the best way to create fonts was to use Fontographer, but in the ever-changing world of computer software, Fontographer is fast becoming outdated, and will not work on the latest operating systems such as OS-X for Mac. A new program, FontLab, is now available to fill that need, though to create fonts from hand-lettering, you will also need to buy ScanFont from the same company. Scanfont's auto-trace capability is included in Fontographer, but not in FontLab. Another factor to consider is font formats, which are in a state of flux. Previously, fonts came in two formats, TrueType and Type 1, and each of these was different for Macintosh or PC systems, so, in effect, there were four formats.

Recently Adobe and Microsoft joined forces to create a new format called OpenType, which combines elements of all the previous formats, and is compatible with all newer systems, though not with some older ones. OpenType has the added advantage of holding many more characters than the older formats. While change is slow to come in the publishing industry, it seems likely that OpenType will eventually become the standard. FontLab is designed to create and work with OpenType as well as all the older formats, and therefore offers more promise for long-term useability. For these reasons, we'll be using FontLab with ScanFont for our examples, though the processes discussed are very similar in Fontographer. We will be using Type 1 format for Macintosh, though you can convert this to other formats if you need to. Both Fontlab and Fontographer are very complex, powerful programs, and we'll only cover a few basic methods. I recommend you study the manuals of whichever one you use to learn more about font creation than we have room for here.

Preparing and tracing the characters with ScanFont

Some of our characters, opened in ScanFont, after the Separate Shapes command is used to create Cells around each one.

ScanFont has some of the tools and operations of scanning, drawing, and painting programs, but we will be using it mainly as a conduit for preparing and tracing our characters and placing them into FontLab. Familiarize yourself with the basic operations of the program, concentrating on Image Splitting and Creating Characters. When you're ready, open your scanned character image in ScanFont. If any of your letter shapes need correction, you can zoom in on them and make changes with the eraser and pencil tools, but don't be too fussy—you don't want them to be perfect, just clearly readable.

Under the Cells menu, choose Separate Shapes. This will bring up a dialogue box where you should make the following choices. After *Use separation method,* choose Book Smart from the pop-

up menu. The box in front of *Skip spots that are less than…* should be checked. The box in front of *Automatically detect global baselines* should be unchecked. Click OK to separate all your characters into Cells.

In a few moments you will see gray boxes surrounding each of your characters. These Cells represent the areas that will be placed into character slots in FontLab. Each box has a separate baseline in blue (see the Elements of a Character diagram above) marking the bottom edge of the character. In an all-uppercase font such as we are creating, these can all stay at the bottom edge of the box, except in the few cases where you want something to extend below the baseline, like the comma and the Q. In those cases, move the baseline up to the appropriate spot. Look through the Cells and choose two favorites for each alphabetical character that you want to keep (except for capital and lowercase I, you only need one each of those). They should be well-formed but visually different to give your font variety. Click on the Cells of any extra, unwanted examples and Delete them. For punctuation, numbers, and special characters you will only want to save one example and Delete the other Cells. If any of your remaining Cells are actually two or more overlapping Cells, select them and under the Cell menu choose Merge Cells. Your punctuation that has added top or bottom guidelines should have them included in their Cell. All your Cells should be roughly the same size. If any are radically different, you can redraw that Cell using the Define Cell tool.

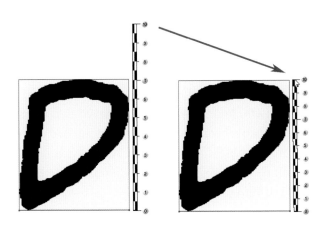

There is one more adjustment that I recommend you make for this kind of font: setting the Scale for each character. Characters in Type 1 fonts use a scale of 1000 units. By default, ScanFont sets the scale of uppercase characters to a height of about 700 units. But in a comics font you will want to use the full 1000 units for most of your characters, so they print as large as possible at any given point size. Select the Scale Tool, then select a Cell. You will see the current Scale of that character from 0 at the baseline to 1000 at the top of the scale. If the character is well below that 1000 mark, click on the top area of the Scale (not the very top) until the cursor becomes an open arrow with a small black square under it. Drag the top of the Scale down to position it near the top of the character, as shown above. Hold the Shift key while dragging to keep the scale bar vertical. You'll need to do this for each Cell. You can make further size adjustments later in FontLab, but this will get your characters to roughly the right size.

Now we'll trace a sample character. Make sure you have FontLab installed on your computer and that you have enough memory to open it along with ScanFont. Select the first Cell at upper left, it doesn't matter which actual character it is. Under the Cells menu choose Place Into Font. An Export to FontLab dialogue box will open. Make no changes, click OK. Next, the Tracing Options dialogue box will open. As shown below, this is where you set how closely your scanned shape will be traced. The goal is to have an accurate tracing using as few points as possible. Extra points will add to your final font size and make it slower to use, as well as harder to edit later. Too few points will remove the individual style of your lettering. Try the different presets on the top pop-up from Very Tight to Very Loose, and use the Zoom tools under the preview to see how these affect your tracing. For regular comics

The Tracing Options dialogue box allows you to preview the way a character will be converted into vector outlines. Try different settings and study the result in the preview box.

alphabets, I recomment the Loose setting as the best compromise, but use your own judgment to get the look you're after. Remember that the final product will reproduce much smaller than it appears here.

You can trace each character individually, but I recommend that you trace all the Cells at the same time. If you want to do this, check the box in front of "Always use these settings for current image." Then click Cancel, and start over. Now Select All your Cells and follow the same procedure. You will now bypass the Tracing Options dialogue box and FontLab will open. Your traced characters will be placed into a new Untitled Font, at the bottom of the open Font window. We're done with ScanFont now, so you can close it after saving your scan file.

Setting up your font in FontLab

Familiarize yourself with the basics of FontLab by reading the manual, concentrating first on basic definitions, windows, and tools. One important term is Glyph. Your new font is displayed in a Font window made up of rows of boxes. Each box in the Font window contains a glyph. There are two capital A's among the items you've scanned and traced. Each represent the Character A, but each are a separate glyph that we will place in different boxes. Before we begin that, we need to name the font and fill out the Font Info. Under the File menu, select Font Info.

In the first window of this box, shown opposite, fill in your font's Family Name. As discussed previously, this is the general name of your font. For instance, in the font Helvetica Bold, the family name is Helvetica. Use something original, and not too long, that you will remember. In the next line choose an appropriate Weight from the popup menu. Use the default, Normal, if you're not sure. If you are creating a Bold or Italic font, check the appropriate boxes. Click the Build Style Name box to automatically fill the next line. Then click the Build Names box at bottom to fill in the rest of the lines. In the menu at the left side of the box, click the small arrow in front of Names and Copyright to reveal additional information boxes you may wish to fill out such as copyright and designer information. You can always add these later. Close the Font Info box when finished. Then Save your new font to a folder you can locate easily, perhaps in the FontLab folder. It will save in FontLab format by default.

The Font window in FontLab, with glyphs being placed.

Now we can begin placing the glyphs in appropriate boxes. Expand the Font window to full-screen size. Notice that your imported glyphs are all at the bottom. Above them are gray boxes that show the images of the characters that should go in each one, matching the correct places on the standard keyboard. Some boxes are empty: these are unassigned spaces that we won't use. We won't use many of the assigned ones either, just those we have glyphs for. Click on one of your Capital A glyphs to select it, and Copy it (Command-C). Then click on the gray box representing Capital A and Paste (Command-V) the glyph into that box. Repeat the process with the other Capital A glyph, but paste it into the space for Lower Case A instead. Continue this process with all your imported glyphs until each has a new home. Then Delete the original copies, you won't need them again. If you're not sure where to put characters, you can use the sample font layout given previously for ideas, but try to follow traditional keyboard placement whenever possible to avoid confusion when typing. When you're done, save your font again. Your font is well underway, but there's more to do!

Double-click on the Capital A glyph in the Font window. This will open the Glyph window for that glyph. Let's set up the working format for the Glyph window by adjusting the views and preferences. (Many of these options are already set by default, so just change those that are not.) The illustration below shows the preferred view for the Glyph window. If the toolbar at the top of the window is missing, click the small box at the right end of the top ruler, as shown. If the Glyphs bar is not shown, click the small arrow at the bottom left of the box, as shown. If any of the other toolbars shown are missing, go to the Views menu at the top of your screen and drag down to toolbars. The following should be checked: Standard, Panels, Tools, Edit, and Show Layers. Click on any that aren't checked to open them.

Then go to the Tools menu at the top of your screen and click on Preferences to open the Preferences window. The popup menu at upper left switches between several preference panels. Under General, check the box in front of Autosave every 10 minutes. Then go to Glyph window in the popup menu. In the Glyph Window Options list, only the following items should be checked: Small Nodes, Black/White Node Icons, Leave Echo When Editing, Highlight First Node of Open Contour, Do Not Fill Open Contours, Bezier Control Points are Visible in Selection. Uncheck all others. Below that list, after Visual Ascender and Descender, change the number in the first box to 110. Click OK to finish editing Preferences.

The Glyph window in FontLab allows you to fine tune each of your letters. The circled boxes will open the various toolbars and palettes you'll be using.

The Preferences dialogue box will help you set up the Glyph window further. The circled number should be typed in as shown.

Now let's look at the Glyph window. If you have it set up as in the example above, you will see three gray dotted lines around the glyph, one at the bottom, one at each side. Referring back to the character diagram, you'll see that the bottom dotted line represents the baseline. The left and right dotted lines are the left and right sidebearings. These form the working area or bounding box that each glyph fits into. You will also see some horizontal lines representing Ascender (A), Cap Height (C), X-Height (X), and Descender (D) that correspond to those elements in the character diagram. By default, the Cap Height is set at 70 (700 units), but we need to move it to 100 (1000 units) for our font. In the top toolbar, click on Editing Layers to open that palette. In the Editing Layers palette, click on the Expand button at upper right to open the full options list. As shown, you will see three rows of check boxes. The left row hides and reveals each layer. Try clicking each one to see what happens. You'll see that the labelled lines we've listed above are in the Vertical Metrics layer. The right line of check boxes locks and unlocks each layer. Unlock the Vertical Metrics layer, then slide the Cap Height line up to the 100 mark. This will now mark the upper height of our bounding box. Relock the layer, and we're ready to begin editing our glyphs.

Look at the Capital A glyph closely, noting the anchor points or nodes that create the outline of the letter. To see what the letter will look like when printed, press the Accent Key on your keyboard (left of the number 1 key). Do this any time you want to check the look of your letter. Now is the time to make any adjustments to the outline of this glyph by using the Edit tool (Arrow) to move the nodes, change the curves of the outlines by moving the Curve Handles of the nodes, or use the Eraser tool to

Clicking the Font Audit button, circled in red, highlights areas on your glyph's outline that might cause problems, each with a red arrow. Click on one to open the Font Audit dialogue box and choose Fix All. Also soften sharp points by adjusting the curve handles of the point, as shown (unless creating a pointed font).

remove excess nodes, but remember that you don't want your letters to look too perfect, and that small imperfections will not be easily visible at working size anyway. When the shape looks right to you, click the FontAudit button on the right end of the Layers toolbox (the Yin/Yang symbol). This will automatically highlight any problem areas of the outine with a red arrow. Click one of the red arrows with the Edit Tool to open a description of the problem and buttons that will fix it. I recommend you click Fix All for this problem, and do the same for any remaining red arrows. FontLab will thus help you create outlines with few if any printing problems. One other thing to look for is very sharply pointed corner nodes. These should be widened by dragging the Curve Handles outward to lessen the sharpness of the corner, making working with the font easier later.

When you've made all those adjustments to the outline of the Capital A glyph, look at how it fits into the bounding box. Ideally each glyph should fill the bounding box from top to bottom, but that would make the letters too much the same, so I recommend having some glyphs be a little smaller than the bounding box, some a little larger, some dropping a bit below the baseline, some a bit above. This will give your font a more casual hand-lettered look. Use the Transform tool in the vertical toolbox on the left of your screen to make quick size and angle adjustments. Experiment with it to see what different results it can give. To see how the letters will look next to each other, open the Preview panel by clicking on that button in the top toolbar. Then either use one of the preset choices in the popup box at the right, or type the letters you want to look at into the Preview panel's editing box. This will give you an idea of how the letters will look when typed. Again, they shouldn't all line up perfectly. Continue editing all your glyphs in the same way. For any punctuation glyphs that include guidelines, select and remove those now. When you're done, we're ready for the next step.

Click on the Preview panel button, circled in red, to open a view of your characters in a row, as they will print.

The Transform tool, circled in red, encloses your glyph in a box. Adjust size with any corner box, angle with the slanted box at top center, and rotation with the circle at right center.

You have all your characters finished, and you're done, right? Not quite. We still need to space and kern the font. This area is the most critical one to make the font look good, and the more care you put into it, the easier your font will be to use. Spacing refers to the amount of space between all the letters. When pairs of letters need special attention because of their shapes, such as V and A, or L and T, a different spacing exception can be set for just that pair. This is called Kerning. Together they are known as Font Metrics. Programs like FontLab and Fontographer have a number of tools to help font creators do this more easily, but unfortunately, they often don't work well with comic book fonts, partly because of their loose, hand-drawn nature, partly because of the unique setup I've described, where a second set of capital letters are in the places usually filled by lowercase letters. I've found that the best way is to begin with the program's automatic Metric features, then manually adjust the Kerning as needed.

The Metrics window, indicated by the blue M box, circled, shows the characters typed into the editing box, also circled, spaced as they will appear when typed.

Under the Windows menu at the top of your screen, open a New Metrics window. In the editing box, type a string of characters to work with, such as Capital A to Capital Z. In the large window, those glyphs will appear. In the upper left of the panel are buttons with a blue M and a red K. These are the Metrics (spacing) and Kerning modes, and you can look at either one at a time. Starting in Metrics, examine the space between your glyphs in the large window. The goal is to have about the same spacing between all the glyphs as the width of your heaviest vertical strokes, such as those in the letters H and N, with a little extra space around the lowercase I and punctuation. You will probably need to make adjustments! Click the button with the green diamond symbol to open the Automatic Metrics dialogue box show on the next page. In the first popup, choose All the characters in current string, then type left and right spacing numbers in the Custom Metrics boxes. I'm using 60 and 60 for our example, but experiment with other numbers to get the spacing you want. When you have the best setting, choose Whole font from the first popup, and repeat the process for all the glyphs. You'll be asked again if you want to do this: you do.

Click on the Automatic Metrics button, circled, to open a dialogue box that will adjust some or all of the spacing in your font. Type different values in the circled boxes to try different spacing.

Some of the spacing between your letters will probably still not be right, and that's fixed by kerning, or adjusting the space between individual pairs of glyphs. In the Metrics window, switch to Kerning mode by clicking the button with a red K at upper left. Clicking on any glyph in the large window will cause a pointed slider to appear to the left of that glyph. This is the Kerning Editor. Use your cursor to slide it right or left until the space between that pair of glyphs is where you want it. This way you can manually kern as many pairs of characters as you like in the font. You might choose to look for just the most obvious ones such as L and T and adjust those. The popup to the right of the editing box has some sample character strings that might help with this. You can also experiment with the Automatic Kerning feature by clicking the button with the green diamond symbol, and trying different settings, as you did with Automatic Metrics. You can use these methods, finish up your font, and then come back later to do more kerning where needed.

Click on the red K box to switch to the Kerning window. This allows adjustment of the space between specific pairs of glyphs, here the Capital A and Capital B, by sliding the Kerning line, circled.

However, I've found that neither of these techniques is very effective with comic book fonts, for the reasons given earlier, and I like to check and manually adjust every possible kerning pair, a long and boring process, but one which will result in a font that has no spacing or kerning problems, and will never have to be fixed again. To do this you need to create a set of sample strings that includes every pair in your font. Here's an example for the Capital A glyph:

Click the circled button to open the Automatic Kerning dialogue box. Experiment with the different settings.

AAABACADAEAFAGAHAIAJAKALAMANAOAPAQARASATAUAVAWAXAYAZA
AaAbAcAdAeAfAgAhAiAjAkAlAmAnAoApAqArAsAtAuAvAwAxAyAzA
A1A2A3A4A5A6A7A8A9A0A!A#A$A%A&A*A(A)A-A{A}A[A]A:A;A"A'A,A.A?A

 Notice that I've included pairs for upper and lowercase, and pairs for numbers and punctuation. You can copy and paste these sample strings into the sample list for the Metrics window, accessed by clicking the button to the far right of the editing box.

Click the circled button to open a list of sample strings that you can add to by typing in the box. You can also prepare your sample strings in a word processor program, then cut and paste them here. The strings shown were created to work with comics fonts. Select a string by clicking on it. Then adjust the kerning for each pair in the string, as needed.

I continue this process for each glyph, though the sample strings get slightly shorter each time; for instance, you'd next begin with BBB, then with CCC, and so on. Don't forget to kern the lowercase glyphs, numbers, and punctuation with themselves and each other. You may also want to adjust the space between words: switch to Metrics and type two short words in the editing box, then adjust the size of the Space Glyph as needed.

There's much more to learn about Font Metrics than we have room for here, so I'd recommend studying your font creation software manual, but following this process will give you a font that always has correct letter spacing, and will not need further adjustment. Whenever you want to check your progress, you can print the contents of the editing box. First, reduce the letters to working size by typing 11 in the Type Size box to the left of the editing box. Make sure you're in Kerning mode, then choose Print from the File menu at the top of your screen to access your printer. This will print the samples at a height of 11 points, roughly the size of your original lettering, and show the effect of your kerning on that sample string. Return the Type Size to Auto when you want to continue kerning.

Any sample string can be printed to see how it will look. Type 11 in the size box, circled, for 11-point type, approximately the size of your original hand lettering. Then choose Print from the File menu. Return the type size to Auto when done.

Generating Font Files

When you're font is complete, or at least ready to try out, you need to create the actual font files your computer needs to use the font. Close all windows in FontLab except the Font window for your new font, and check the glyphs once more to make sure they're all in the places you intended, and there are no extra, unneeded copies at the end of the window. Then under the File menu at the top of your screen

choose Generate Mac Suitcase. (We're creating a Macintosh Type 1 font for our example. If you wanted to create a PC or OpenType font, you'd choose Generate Font.) A dialogue box will open that should show your font's files as in the example below: your font's enclosing Suitcase at the top, and the font files below in the appropriate sub-section: Plain, Bold, Italic, or Bold Italic. The categories we chose when naming the font originally will determine this, but you could change them now if they're not correct. Under Plain in our example are three files: the printer file and two screen or bitmap files, one for 10 point, one for 12 point. Type 1 fonts require both printer and bitmap files to work on your computer, but you only need one bitmap file. You can click on the 10-point file and click the minus button to delete it.

Then click OK, and you will be asked where you want to save the Font Suitcase. Choose a file or create a new one for your finished fonts, perhaps in the FontLab Folder, and click Save. Copy this master version to your computer's Fonts Folder, or use a type utility like Extensis Suitcase to manage your fonts, turning them on and off as needed.

We're finally done, and nearly ready to move on. That's the good news, but the bad news is you will probably need more fonts. For general balloon lettering you will need at least two versions of your font: Plain and Bold Italic (for emphasized words). You may also want to create an Italic version, useful for things like poetry or song lyrics. Each of these should be created separately for best results, though you can use the tools in FontLab to create slanted and bolder versions of your original font. You will still probably have to adjust the kerning on them, though. These versions are all part of your Font Family, and can go in one Suitcase.

All the above font creation methods can be used to make other kinds of fonts, such as display, sound effect, and title fonts, with a few differences. First, since you'll be creating those alphabets at a larger size, you can scan them at 100 percent. When you set your Tracing Options in ScanFont, experiment with different trace settings. Aim for an accurate trace that doesn't add excess points. For creating very precise title fonts, you can draw them first in Illustrator (see below) with the Pen and Shape tools, then save in EPS format, open with ScanFont, and place into FontLab. Finally, when spacing and kerning, you'll need to consider how the letters will look at a larger size, and may want to space and kern them closer than balloon text fonts. It takes time, but when you've created some fonts, or if you have some commercial fonts ready, it's time to start lettering!

IN ADDITION TO YOUR REGULAR, *ITALIC* AND **BOLD ITALIC** BALLOON FONTS, YOU MAY WANT TO CREATE SOME SOUND EFFECT AND TITLE FONTS, SUCH AS:

BLAM! BOOM! KRASH! POW! SKRATCH! WOOSH! ZAP! ART NOUVEAU Blackletter ART DECO DISPLAY DISPLAY NARROW MODERN CURVED BLOCK HEAVY BLOCK BOLD THORN

Lettering Balloons in Illustrator

Familiarize yourself with Adobe Illustrator by going over the manual and using the tutorials. When you're ready, open a New File (Document) in Illustrator in CMYK mode. Open the Layers palette and create two layers, the top one labelled Letters and the bottom one labelled Balloons. Open the Character palette and open the Options with the arrow at upper right. Scroll through the Fonts to the comic book font you want to use. We're going to work at original art size, so below that, set the Type Size to 11 points and the Leading to 11.5 points. Leading is the vertical space between rows of type, and is an important aspect of computer lettering: too little and the words are cramped and hard to read, too much and they take up excess space. I like the ratio of 11 over 11.5 for balloon text lettering, but you can try other values. Open the Paragraph palette and set it to Align Center.

Setting up Illustrator for comics lettering. palettes you will need are circled in red.

Now click on the Letters Layer in the Layers palette, and with the Type tool, click on the document surface and type a short sentence. You may want to enlarge the View to 200 percent or more see your type clearly. To add variety, use some of the uppercase alternates in the font, especially when you have doubles of the same letter next to each other. Remember to only use the uppercase I for the personal pronoun I and contractions.

You have a sentence, now think of how it has to be broken into several lines to fit into an oval balloon: longest line or lines in the center, shorter ones at the beginning and end. Break up your sentence that way by clicking the Type tool at the break point and hitting the Return key.

When you're happy with the shape of the text, click on the Balloons Layer in the Layers palette. Type always enters as 100 percent black, but for our balloon we want a different color choice—a white balloon with a black border. This is where you need to use the Fill and Stroke features of the drawing program. These are shown on the Tools palette as a solid box and an open box. Click on the solid box to select it, then open the Swatches palette and click on the White swatch. The Fill box will turn white. Click on the Stroke box to select it, then in the Swatches palette click on the Black swatch. You can make sure you've chosen 100 percent black by opening the Colors palette and opening Options with the arrow at upper right. The bottom slider of the Colors palette indicates 100 percent Black. All others should be at 0 percent. Your balloon stroke and fill are now set.

Choose the Ellipse tool, and with the Option key held down (to drag from the center), place the cursor at the center of your type. Then click and drag the mouse down and right to create the balloon shape. Try to leave about a character-width of white space around all the lettering. If your balloon is off-center, use the arrow keys to nudge it to the center. You can also change the balloon size by dragging the side handles or individual anchor points. The default Stroke Width is 1 point, but I prefer 1.5 points at this size. Open the Stroke palette, and in the Weight box enter 1.5 pt. Your balloon will show that change if it's still selected.

Now for the tail. Decide where you want the tail to join the balloon, and with the Pen tool, click just inside the balloon border to place the first

Circled at left are the Fill and Stroke boxes on the control panel, which also appear on the Color palette. Clicking on either will bring it to the front. The Stroke is chosen here, showing 100 percent black. In the Swatches palette the black swatch is chosen, and in the Stroke palette we see the stroke weight is 1 point.

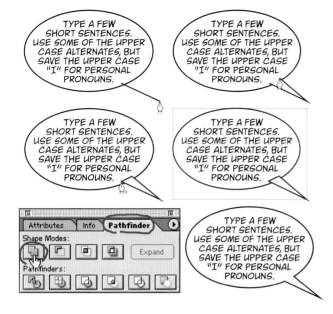

anchor point of the tail. Click again outside the balloon where you want the point of the tail to be. Click a third time inside the balloon to make the other side of the tail, then position the Pen tool over your first point. A small circle will appear to show that you can close the path. Click, and you have a straight tail. To create a curved tail, experiment with clicking and dragging at the same time on your first and third point to extend the curve handles. This takes some practice, but you'll get the idea.

All that remains is to join the tail to the balloon. Click on both of these to select them, then open the Pathfinder palette, and click the Unite (Add) box (while holding down the Option key in the latest version of Illustrator). Does your tail have a blunt end instead of a sharp point? You can fix that in the Stroke palette. In the Miter Limit box, type a larger number, such as 40. Congratulations, you've now lettered your first balloon! Practice these techniques until they become second nature.

Additional Lettering Techniques

If you want to emphasize some words, you need to change the font to the Bold Italic style. Do that by first double-clicking the word to select it (or drag the Type tool across the letters), then in the Character palette, double-click in the Style box (after the Font name). Type the first letter of the style you want, such as B for Bold Italic, then hit the Return key and the word will change styles. You'll want to set all the styles and finalize the type position before you draw the balloons.

Having trouble getting your sentence to form the correct oval shape? Hyphenating long words can help—check a dictionary for the correct break points if you're not sure. You can also adjust the width of an individual line. Drag the Type tool across the line to select it. In the

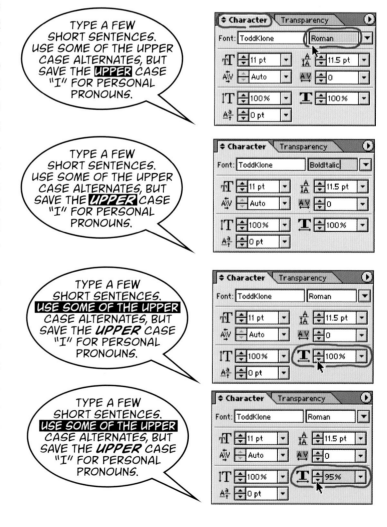

Character palette, look for the Horizontal Scale box. Increase or decrease the percentage with the arrow keys to change the line width, but don't go below 90 percent or above 110 percent, or your type will look distorted. As mentioned earlier, you can also adjust the shape of your balloon after it's created by moving the anchor points and adjusting the curve handles. You may want to do this anyway to keep the balloons from all looking too much the same.

Are some letters too close together or too far apart? First, make sure the Kerning box in the Character palette is set for Auto. If it is, you have a kerning error. For a quick fix, click the Type tool between the letters, and with the Option key held down, kern with the arrow keys. You'll have to do this every time that combination appears, though. Fixing the kerning in the font with FontLab will give you a permanent solution.

Use the same techniques for lettering captions, but with these differences: in the Paragraph palette click Align Left, and when creating the caption box, choose the Rectangle tool and begin your click and drag, without the Option key, above and left of the type.

Other balloon shapes can be created in several ways. First, you can use the pen tool to draw balloons point by point. This works best for straight-edged bursts, but can also work for other shapes, with some practice. You can also create more free-form shapes using the pencil tool. If you have a hard time handling these tools with the mouse, consider buying a computer drawing tablet, such as those made by Wacom, which allows you to move the tools with an electronic pen over a tablet surface.

Some of Illustrator's Filters, under the Filter menu, can also be used to create balloon shapes. The Roughen Filter can create various rough or wobbly balloons—experiment with the settings. Electric and thought balloons can be created using the Pucker and Bloat Filter, though you'll need to add extra points to your basic ellipse shape with the Pen tool first. Try the other filters, too. You might get effects you like. Whisper balloons can be created easily using the Dashed Line section of the

PRON OUNS.

PRONOUNS.

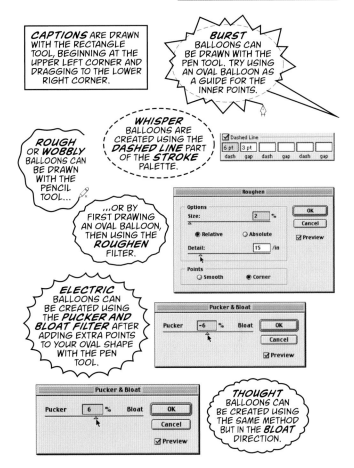

Stroke palette. Once you've created a special balloon shape, you may be able to use it again. Create a new file called Balloon Shapes, and Copy and Save your best examples to it for future use.

Thus far, we've been working at original art size, but on the computer you can work at any size. You'll need to adjust the size of your fonts and strokes, though. For instance, at printed comics size, I like to set my regular lettering font at 7 points with 7.4 leading, and use a 1 point stroke for balloons. Experiment with different settings to find the one that looks right for your font and working size.

Display Lettering and Sound Effects

Display lettering, as we discussed in the Hand Lettering section, is used when you need some extra emphasis or attention. You can do that by just using your comic book fonts at larger sizes; but designing specific Display Fonts will look better and give you more variety. Some of those same fonts will work as Sound Effects, too, or you can find commercial fonts to help fill that need. When display letters fall outside a balloon or are very large, they look better as open letters with a black outline. Here's how to do that.

In the Layers palette create two new layers below Balloons. Label these SFX1 and SFX2. Click SFX1 to select it, then in the document type in the words you want using a Display Font. (A) Position and kern them as necessary; then, with the words selected, use the Create Outlines command under the Type menu, giving you outline shapes with a fill of Black and a stroke of None. (B) Ungroup each word, and arrange, angle, and size each letter for variety, then regroup. We could create outline letters the same way we created balloons, by giving the letters a fill of white and a stroke of black, but that isn't the best way to go here, because the black stroke will fall inside the letter shapes, changing them in ways we don't want. Remember that the reader will see the letter shape as the inner, white space, not the outline, so we have to preserve that white area.

Fill your letters with White, then hit the Command and C keys together to Copy the letters. Next hit the Command and B keys together to Paste in Back. Go to the Layers palette. You'll see the SFX1 Layer is highlighted, and that a small color box is showing at the right end. With your cursor, move this box down to the SFX2 Layer. We've moved an identical copy of your white letters to the lower layer. Now give that copy a fill of Black and a stroke of Black. (C) In the Stroke palette, increase the Weight until the black outine behind the white fill is as thick as you want it. If sharp points are cut off, increase the Miter Limit to a higher number. Or, if you want all the outline to have rounded corners, change the Join to Rounded by clicking on the appropriate box to the right of the Miter Limit. You've now created outline letters in two layers. In front are white letters that can contain color (we'll talk about that later). Behind it are identical letters with a Black Stroke. Using separate layers will make them easier to work with.

Additional effects on the outlines in SFX2 can be added for more variety. (D) Try experimenting with the Roughen Filter, or using the Dashed Line option in the Stroke palette. Adding additional layers with effects below SFX2 can often give interesting results, as shown in the examples above. Create a drop shadow by moving a copy slightly down and to one side. For an open drop shadow, Copy and Paste in Front (Command and F keys), then give a stroke of None and a fill of White, or a smaller stroke of White. To add an outline outside all the letters, experiment with the Offset Path command under the Object menu. Some of these same techniques can be used to add a variety of effects to your balloon shapes, too. Remember always to keep it readable!

Titles, Credits, and Logos

Titles and Credits are an area where your computer and your design sense can combine to create some striking effects that will help make your work stand out. Choose fonts that will reflect the style of the story you're lettering, as well as the meaning of the title itself. Look for unusual fonts that will help enhance the drama and mood. When working with comics art, look for interesting ways to work in your titles and credits without distracting from the story. Look at how others have solved these problems in your favorite comics, and also look at all kinds of title work in magazines and movies, and on TV. Designing with type is an art in itself, and you may find some helpful books on the subject. One advantage of the computer here is that you are free to try things, then reject them if they don't look good, without having to actually draw the letters each time.

An inventive variety of title and credits lettering from various DC books by Ken Lopez.

The same applies to Logo Design, an area where the computer is especially helpful. After coming up with your design idea and either scanning and tracing it in Illustrator (or using fonts to begin with), you can create a wide variety of different logo treatments quickly without having to draw each one, as you would when working by hand. Combining the techniques we've discussed with a strong, original concept is the best way to come up with logo designs that succeed.

Logo designs on the computer often begin with an existing font, as shown here, though you can also begin with a hand-drawn design that you scan and trace in Illustrator.

TWENTY-TWO
WORKING WITH ART
AND SCANS

When doing computer lettering for a publisher, you will often be provided with scans of the artwork to letter over. In some cases you may need to make those scans yourself. A large-format scanner that can handle a full page of comics art is a great time-saver, though you can use a smaller and much cheaper scanner by scanning the art in halves, and combining the halves in Photoshop. When scanning for lettering placement only, a scan of 150 dpi is usually detailed enough. Below that, you may have trouble placing the edges of your balloons correctly. Make your scan using the 1-bit Line Art format whenever possible, adjusting the brightness to pull in the details you need, to see what you're doing. Save the scan in TIFF format.

When you have your scans and are ready to begin, start by creating a Template for yourself in Illustrator. Create a New File, then adjust the Document Setup under the File menu to reflect the size of the scans you have. If you're working at printed size, you can use the Letter size. If working at original art size, use the Tabloid size, both using Portrait Orientation (short side at the top and bottom). You may want to adjust the Page Size also, to best fit your printer, for when you want to print out a sample of your work.

An example of scanned art from *Wonder Woman* #200 (March, 2004). This is full-bleed art. I've added solid crop and broken safe-area marks on the margins.

Next, go to the Layers palette and create these layers, from top down: Lettering, Balloons, SFX1, SFX2, Art. Use the Place command under the File menu to place one of your scans in the file. Put it on the Art Layer. Double-click on the Art Layer to open its dialogue box. Check the box in front of Dim images to… and type in 30 percent. Click OK. The scan is dimmed to light gray. Lock the Art Layer so your scan won't move by clicking the Lock box at the left of the layer name. Now you want to create some guidelines to mark the edges of your scan and also the safe area for lettering, if you can.

Set up a template with layers as shown, placing your art scan in the Art Layer. Draw a box the same size as the outer bleed line, and make it a Guide (under the View menu: Guides: Make Guides). Drag horizontal and vertical guides from the rulers to mark the trim and safe areas. Then delete your scan and save.

Under the View menu, click Show Ruler. This will put a ruler on the top and left side of your document. To create a horizontal guide, click your cursor on the top ruler and drag down. A guideline will come with the cursor and be positioned wherever you release it. Do the same for vertical guides using the left ruler. If you need to make adustments, click Lock Guides under the View menu to unlock them (default is Locked). When you have all your guides in place, click Lock Guides again to lock them. Now Delete your scan. Name your template something like NameMan_43.xx.ai using the book title, issue number, and x's for page numbers.

For each page of your lettering, you begin by opening this template, positioning your scan, Dimming the scan (so you can see what you're doing), locking the Art Layer, choosing the Lettering Layer, then using the Save As command under the File menu to save that file, changing the page number x's to the actual page number. Note that if you're working for DC or another large company, they may supply you with a template like the one below. There you simply need to fill in the project name and page number, place and lock your scan, and rename the template appropriately.

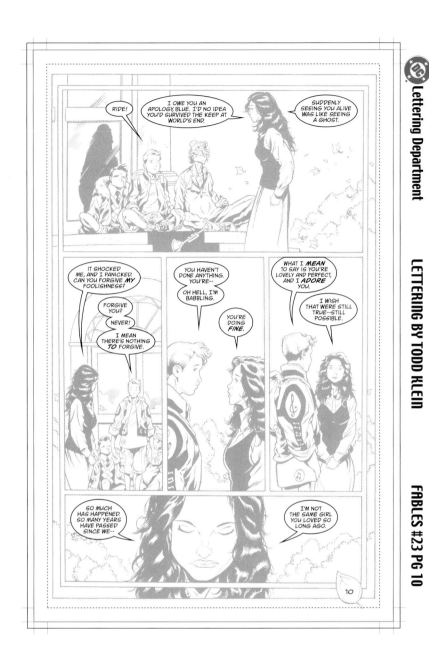

Here's DC's lettering template containing a page of lettering from *Fables* #23 (May 2004). Note that the bleed border is in black, the trim line is a green box, and the safe area is a broken red box. I've added blue trim and safe-area marks to show where they would fall at the art edges.

Another thing to consider is how the lettering will be aligned with the finished art. This is called registration. One method is to draw a thin Black line over the upper-left corner of the first panel to show the correct placement. If your art scan is a copy of the final art file, you can also align the lettering by placing a small Black dot over the upper-left and lower-right corners of the scan. Check with your publisher or editor for these or other methods they prefer. When working with a publisher's template, you may only need to correctly align the art scan to the upper-left corner of the template box, as shown opposite.

As you letter the text, either following a balloon placement provided, or placing them yourself, you may need to have balloons next to borders, requiring straight sides. Draw your balloon as usual, then use the Pen tool to create another balloon-style object that follows the panel border and overlaps the parts of the balloon that go out of the panel, as shown in the example. Then choose both objects

To align the art correctly on the DC template, simply drag the art to the bleed line, assuming the art scan is exactly bleed size, as this one is. The process is actually easier in Outline mode (View menu), where the edges of both art and bleed box are the same-size line.

and, in the Pathfinder palette, click the Minus Front (Subtract) box (while holding down the Option key in the latest version of Illustrator). This will delete the front shape and cut through the balloon behind it so it now follows the panel border.

When you've completed the lettering for a page, you'll want to print it out to see how it looks. Unlock the Art Layer and Undim the scan, then Print the document. If your file won't fit on one page, you can also copy the entire contents using the Select All command under the Edit menu, then open a new document, set the Page and Document Sizes to match your printer, Paste your file contents, and use the Scale tool to reduce it all to fit onto the printed page size of your printer. If you'll be doing this for each page, create a Print Template that you can use for that purpose. You may want to type the file name somewhere in the print area for reference, too, if it's not there already.

To trim excess balloon area from the panel edge, draw a shape as shown, Select both, and click the Minus Front button on the Pathfinder palette.

TWENTY-THREE
WORKING WITH COLOR

When your lettering will be used as an electronic file (rather than printed out and pasted on artwork), you may be asked to color in sound effects and use color in some balloons or captions. We won't get deep into color choices here—that's a topic for the color section of this book—but there are things you should know about working with color in a drawing program.

First, you should always be in CMYK mode when working with color. This is the format for printing. RGB format is mainly for on-screen use. Never use Spot Colors in the Swatches palette (marked with a special symbol), always choose from a combination of Cyan (Blue), Magenta (Red), Yellow, and Blac(K): CMYK. (Spot colors require special ink at the printer, at high expense.)

Some examples of color use in a word balloon. First, a Fill of 100 percent Y(ellow), Stroke of 100 percent K (blacK). Next, the same balloon with the type 100 percemt M(agenta), 100 percent Y(ellow). Finally, a balloon with 100 percent K (blacK) Fill, and Stroke of 100 percent M, 100 percent Y. The letters are white, and I've added a .25-point Stroke of white to make them print better, as thin white areas tend to narrow a bit when printed.

If filling in a white balloon with a color for a special effect, choose one light enough to keep the type readable, unless you make the type White. Then you can use a dark color or Black, but remember that other colors around the balloon may make it hard to see. When making the lettering itself a color, it's best to use a solid color or combination to keep it more readable. 100 percent C(yan), or 100 percent M(agenta) plus 100 percent Y(ellow) are two good choices. When filling open Display Lettering or Sound Effects with color, choosing lighter colors or percentages is often wise, as they will show up better against the rest of the colors. Color can also be used in a Gradient: a blend that runs across two or more colors. You may have some preset Gradients in your Swatch palette, and can create your own in the Gradient palette. Use these sparingly, and with gradual blends to avoid making things hard to read. Note that Gradients can only be used as Fills not as Strokes in Illustrator.

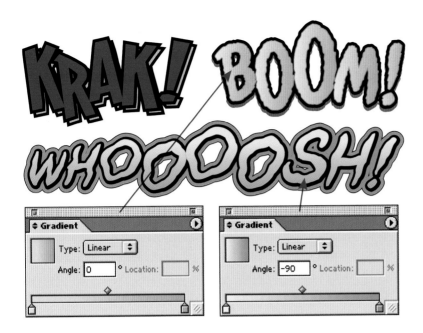

Here's our previous display lettering with color. The solid red (100 percent M, 100 percent Y) filling the first one is probably as dark as I would normally go on a sound effect. The other two have gradient Fills, as shown. Create your own gradients by dragging swatches from the Swatch palette to the bottom of the gradient bar, or by selecting existing colors there and changing the percentages in the Color palette. Save your new gradients by dragging from the Fill box on the toolbar to the Swatches palette.

When a colored Illustrator object is printed, each color usually stops abruptly at the edge of its outline or stroke. In the first example shown below, notice how a thin white edge appears around the letters where the two colors don't quite align properly in printing. This kind of problem can be avoided by the use of Overprinting. In the Attributes palette, you can Overprint any selected object's Fill or Stroke or both. This means that, instead of stopping abruptly, that color will print on top of the color under it. That's shown in the second example. Generally you want to Overprint the Fill of any type that's in front of a colored balloon, and you want to also overprint the Black Stroke of that balloon, as shown here.

It gets trickier with open lettering. To avoid white edges there, always put at least a very thin Stroke around your color Fill on the top layer. Use the same color as the Fill when you can. For letters filled with a Gradient, use a color that's close to the main Gradient color. Then Overprint only the Stroke, not the Fill. This will let the edges run over the outlines in the layer behind. Illustrator now provides a helpful Overprint Preview mode under the View menu that will show you exactly what your Overprint choices will look like in print. Don't forget to check it if you're not sure!

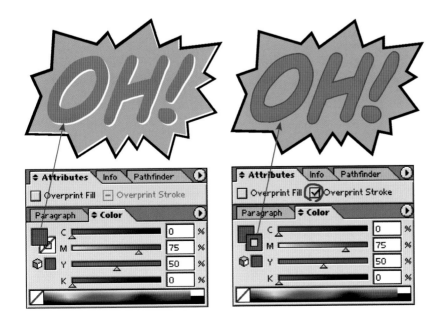

At left is an exaggerated example of incorrect overprinting. By default, Illustrator removes any color behind another color, which can create unwanted white edges, as shown, when printed. At right, a thin Stroke (.5 point at original art size, or .25 point at printed size) of the same color as the Fill has been set to Overprint Stroke in the Attributes palette. Now the Stroke prints on top of the background, eliminating any chance of a white edge. The same thing has been done to the balloon's Stroke. When not sure how such choices will look, check the Overprint Preview mode (View menu).

At some point after you've finished your lettering, it has to be combined with the finished artwork. When and how that happens will determine what you need to do to finish your work. Before that, you need to get the work proofread and approved. Often, you can simply print out your lettering and either send or fax it to the editor or writer. Another method is to use Illustrator to create PDF files of your work that can be emailed and opened with Adobe Acrobat. Make sure you get everyone's approval on the work who needs to see it. When you have all the corrections or changes, make them on your files, and you're ready for the final steps.

Will the lettering be printed out and pasted on original artwork? Then all you need are good printouts. Refer to the Hand Lettering section on doing lettering paste-ups yourself. Otherwise, you need to create a Final Lettering File for each page that you can email or send on a CD or other storage media to your client. We'll do that with a single page, step by step.

Open your lettering file. Make sure all the layers are unlocked in the Layers palette, and if you might have locked any objects, use the Unlock All command in the Object menu to unlock them. Delete any file names, or other placement data that you don't want to print in the final product. In the DC Template shown earlier, all of this is on the top layer. Delete the placed art scan in the Art Layer. You should now see only your lettering and any registration marks you've added to help position the lettering on the artwork.

Next click on the Lettering Layer while holding the Option key. This will select everything on the Lettering Layer. You need to turn your type into outlines, so use the Create Outlines command under the Type menu. It's a good idea to then select Overprint Fill on the type in the Attributes menu, even if none of it is printing over color (unless some of the type is white, don't do it for that). Making that part of your routine helps you avoid forgetting it.

Then Option-click on the Balloons Layer to select all the balloons and captions. If any require color, make sure they have it. You'll want to Overprint Stroke on all, in most cases, again to avoid forgetting any

Sample of a lettered Wonder Woman page in Adobe Acrobat (PDF format). With the full version of Acrobat, you can add pages to this one, creating a proofreading/approval copy of an entire lettering assignment in one document. Note that any fonts you've used that aren't always turned on in your system will need to be converted to Outlines first. Fonts that are permanently on will be imbedded in the document, but unavailable to the viewer.

that will print over color. Option-click on the SFX1 Layer. If anything is selected, make sure it has a color (if wanted) and the correct Overprint setting (check the Overprint Preview mode to view your settings). Your file should now be ready for printing, but check with your publisher for any other special instructions they may have.

Use the Save As command under the File menu to save your file in the Illustrator EPS format, and with a new name, such as NameMan_43.01.ltrs.eps or ending in FINAL.eps. Some publishers may ask for a specific file name format to keep the work straight in their system. Make sure you save a copy for your own records as well as one to send. Put the final files together in one Folder on your desktop and transfer to a CD or other storage media, or email them to your client. Always keep a backup copy somewhere off your main hard drive, in case of any problems later.

One final thought about protecting your work. Instead of Creating Outlines for all your type, you could simply send the fonts with the finished job. Before you do that, think about all the work you've put into creating those fonts, and consider that, once out of your hands, they could be used by anyone to create new lettering. For that reason, I suggest you try to avoid giving your fonts to anyone. This can be a problem when working with others in a studio situation, and you'll have to make your own

choices there, but remember that fonts are easy to use and copy, but difficult to create. If someone needs corrections, it's best to offer always to do them yourself, or suggest the use of a commercial font instead for emergency situations.

Lettering is a small part of the whole comics picture, but one that has a large effect, especially if done well. I hope I've given you the knowledge you need to go out there and make comics better, one letter at a time, and have some fun while you're at it!

Save your final lettering file in Illustrator EPS format. It will later be combined with the art in a page layout program such as Quark Xpress, usually by the publisher. Check with your publisher to establish the naming format.

To create a final lettering file for this page, we've deleted the file info at the right side, and the art scan. In the Lettering layer, Create Outlines of all the type and Overprint Fill on All in the Attributes panel (except when lettering is white or lighter than the balloon color). In the Balloon layer, set All to Overprint Stroke (unless using a white or light border). Or you can simply set any colored balloons/captions to Overprint Stroke. The open sound effect, as shown in the enlarged View, is created from two layers: in SFX1 a Stroke of yellow, in SFX2 a thicker Stroke of red. In this case, setting the Stroke in SFX1 to Overprint Stroke would cause it to disappear into the red Stroke below! Always check Overprint Preview when not sure of your Overprint choices to see how they would look when printed.

INDEX